Simply Paint

BIRDS

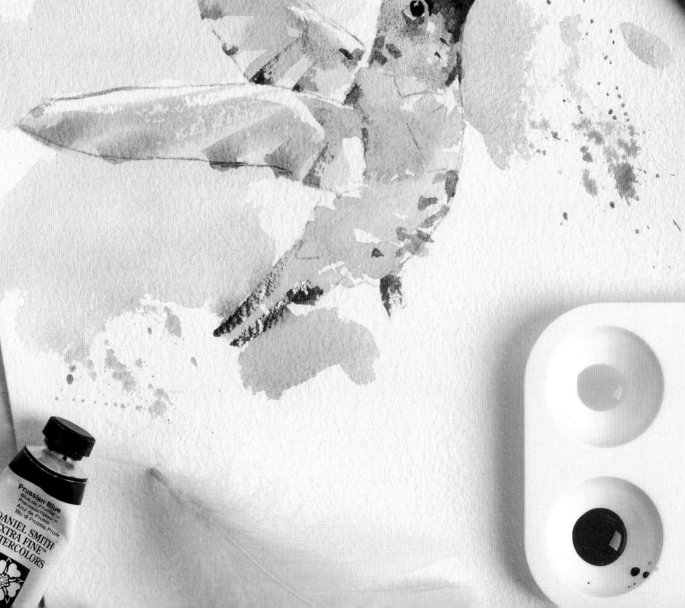

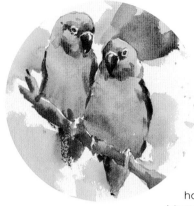

Acknowledgements

I must first thank my parents, Lesley and Neil, for instilling in me a sense of wonder in the natural world; all the time holding a safe space for me to draw and create as a kid. They have always (and still do) supported all of my wacky ideas – even the ones they may not completely agree with!

A huge thanks also to my brother and sister, Lucy and Spike (Alex), for making growing up such a great time. Full of adventure, fun and laughter – all of which continue now!

To Clio, for your never-ending and unwavering support, and so much more which would take pages to write. Also to my two magical children who keep me young at heart and curious about the world (two essential elements to being an artist).

My other close family are all such a creative bunch. Having such imaginative and hands-on people around me, particularly whilst growing up, has been instrumental in my life so far as an artist.

My close friends, past and present – you all know who you are and how important you have been on the journey.

Finally, all of the team at Search Press, for making the creation of my first ever book an extremely fun and creative endeavour.

First published in 2024

Search Press Limited
Wellwood, North Farm Road,
Tunbridge Wells, Kent TN2 3DR

Text copyright © Tom Shepherd 2024

Photographs by Mark Davison at Search Press Studios, except for pages 1–3, 7, 22–23, 25, 29, 33, 37, 41, 45, 49, 53, 57, 61, 65, 69, 73, 77, 81, 85, 89, 93, 97, 101, 105, 109, 113, 117, 121, 125 and 128, by Stacy Grant

Photography and design copyright
© Search Press Ltd. 2024

ISBN: 978-1-80092-179-5
ebook ISBN: 978-1-80093-164-0

The Publishers and authors can accept no responsibility for any consequences arising from the information, advice or instructions given in this publication.

Suppliers
If you have difficulty in obtaining any of the materials and equipment mentioned in this book, then please visit the Search Press website for details of suppliers: www.searchpress.com

Copies of the outlines are available to download for free from the Bookmarked Hub. Search for this book by title or ISBN: the files can be found under 'Book Extras'. Membership of the Bookmarked online community is free: www.bookmarkedhub.com

To see more of the author's work, visit: www.tomshepherdart.com

TOM SHEPHERD

Simply Paint
BIRDS
A complete watercolour course for beginners

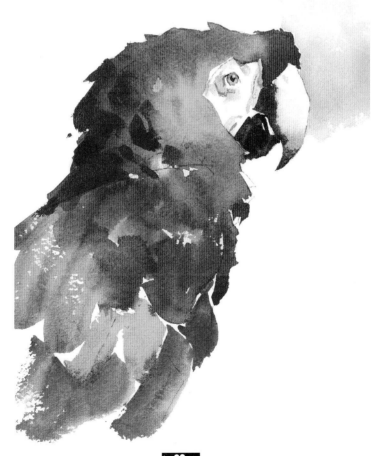

SEARCH PRESS

Cont

Introduction 6
Materials 8
Techniques and tips 12

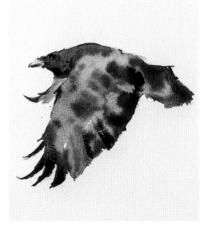
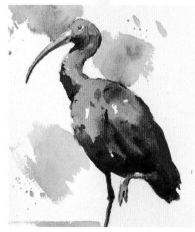
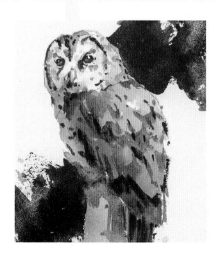

ents

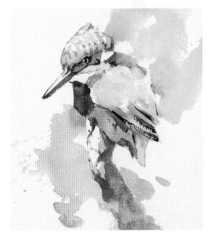
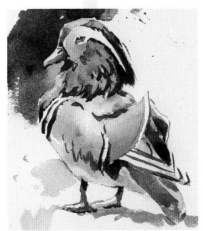
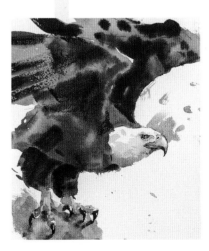

Introduction

Welcome to *Simply Paint Birds*. This subject and watercolours were made for each other! We tend to spot birds in fleeting glimpses of ever-changing energy and movement – particularly in flight – and this makes them a fascinating subject. The free-flowing and spontaneous nature of watercolour makes it the perfect medium to paint this character and energy.

I have been fascinated by the world of birds for as long as I can remember. In fact, 'bird' was my very first word as a baby! Wherever we are, there is at least one species not too far away. This book will show you how to capture their huge variety, character and colour in as simple a way as possible, while still being sensitive to the features of each species, and with enough detail to breathe life into them.

I have chosen a broad range of birds for this book – both in the hope that everyone will find a few favourites in the mix, and also to gradually introduce all the techniques and tips for successful watercolour painting. Whatever your current level of painting, by the end of this book, you will find you can happily branch out on your own, well-equipped in all aspects of watercolour, to tackle any bird you are inspired to paint.

Watercolour is a spontaneous and joyous medium, seemingly with a life of its own. It is not always controllable, which can take some getting used to, but within minutes you will find the fun in the simple act of laying down a fresh wash of vibrant colour on the page and letting the medium do its thing! This attitude of fun experimentation and enjoying the medium is at the heart of this book and should be held at the forefront of your mind while painting these birds.

If you find yourself taking it a little too seriously and getting tense, relax those shoulders, have a quick smile and remember to keep it simple! Trust me: watercolour will love you when you do this, and while you may not get exactly what you had first intended, you will get something you like far more than you could have imagined!

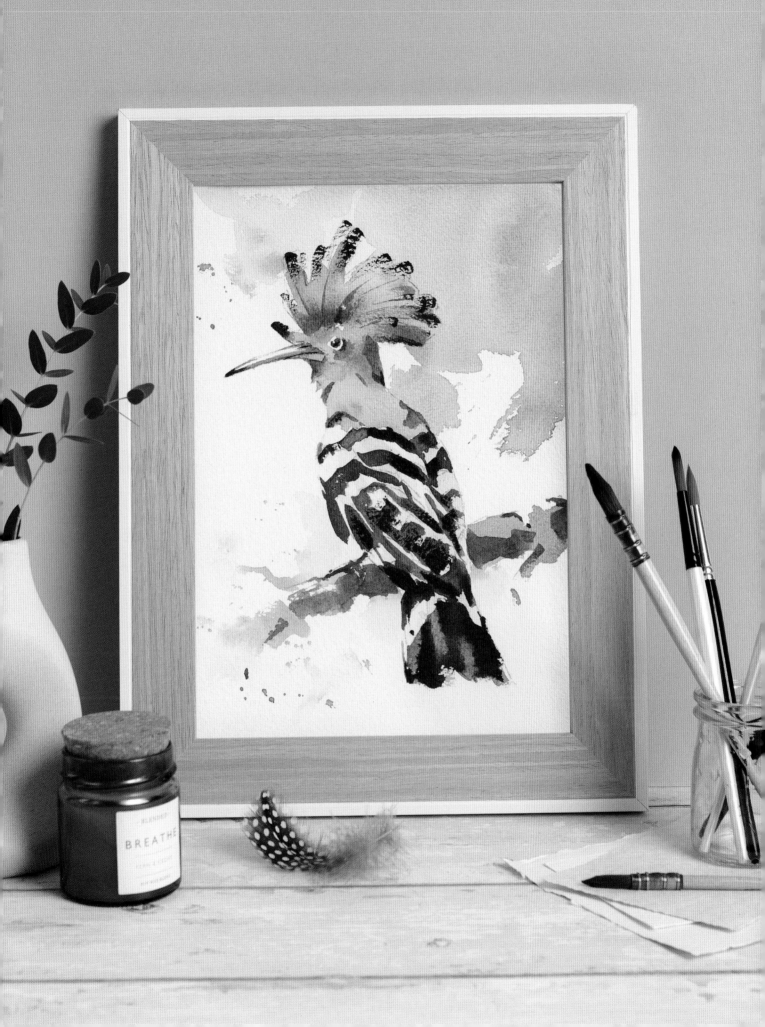

Materials

Let's have a look at your toolkit. If you've ever dabbled in painting before, you may already have some of these products lying around. But if not, you don't need to break the bank by buying top-quality paint or the finest brushes. Almost all the products I use regularly are inexpensive and readily availble from high-street stores or easily found online. Below is what I recommend. If you choose something different, that's fine – just look for materials that have similar qualities and you won't need to make any adjustments to the instructions.

PAINT

I prefer Daniel Smith watercolours because they're juicy and packed full of pigment. Generally speaking, you can mix what you need with just six paints: three cool primaries and three warm primaries. For this book, I've selected some particular favourites and added a couple of fun extras for variety or to capture a particular hue. They are: Prussian blue and phthalo blue (green shade) – both cool blues – French ultramarine and/or cobalt blue, which are my warm blues. The other primary colours are quinacridone red (a cool red), pyrrol red (a warm red), new gamboge (warm yellow) and aureolin (cool yellow).

In addition to these, I occasionally use cobalt teal blue, which is a vibrant turquoise, perfect for details on particular tropical birds; and lavender, a soft greyish paint that is very versatile. You may find some opaque white useful for finishing touches. You can use titanium white watercolour, or – my preference – white gouache.

BRUSHES

Like the paints, you don't need many of these. We'll use a size 1 mop from the Red Dot Collection by Rosemary & Co. for the majority of the washes and larger marks. This brush is a synthetic sable, which means it will hold lots of water and pigment, but won't let the paint flood out when you touch it to the surface. You'll also need a smaller brush for finishing touches and details. I recommend a series 304 size 3/0 (or 000) synthetic, also from Rosemary & Co.

For the more expressive paintings at the end, a slightly larger mop is also useful: such as a size 12 mop from the Panart Premium range. This holds even more paint, but still comes to a fine point for control.

PALETTE

A simple plastic paint palette is perfect. They are inexpensive and can be easily found at most stationery stores. You could also use an old saucer or porcelain tile, but it's quite handy to have a palette with separate mixing pans.

Pictured opposite is a very handy all-in-one travel palette and paint storage tin, made by Brass Bug paint boxes.

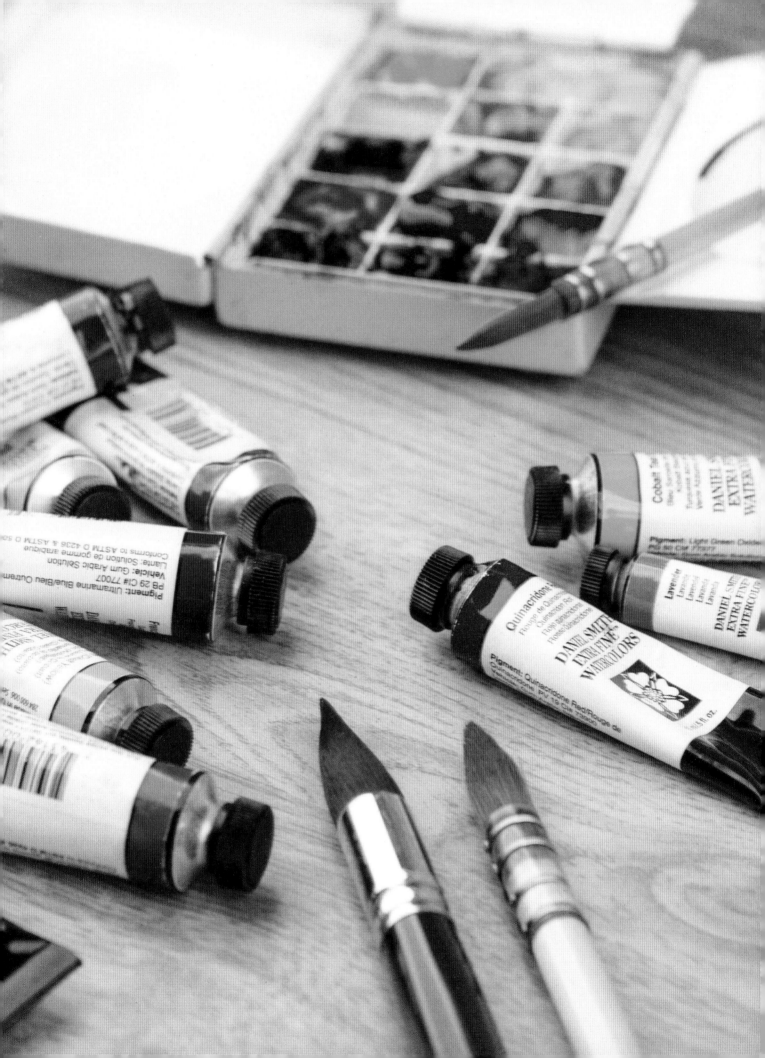

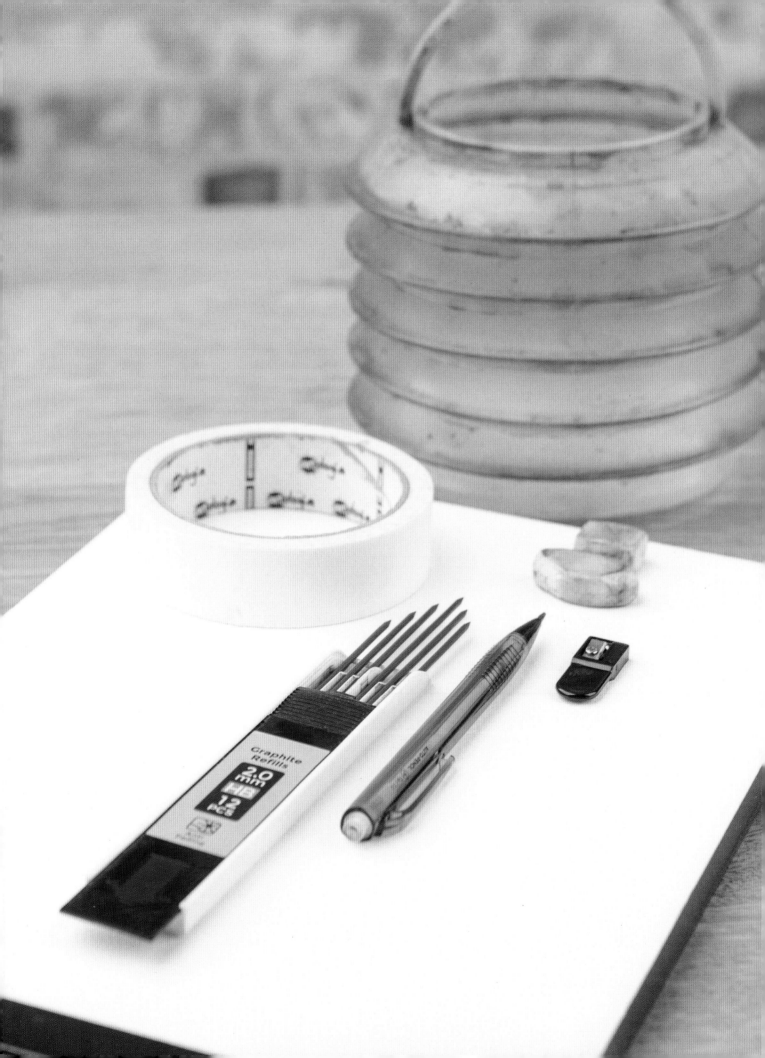

PAPER

I believe the paper used makes the biggest difference to the feel of watercolour painting, and as such, it is a very personal choice. Therefore, if you already have a favourite paper, use that. All the paintings in this book were painted on The Masters' Choice by Baohong (often listed simply as 'Professional'), at A4 (210 x 297mm/8¼ x 11¾in) size. This is a particularly forgiving paper which takes colour very well and stays wet a good amount of time. I favour the Rough texture surface, which creates wonderful broken brushstrokes, but also highly recommend the Cold-Pressed variety.

If you are just starting out, you can use any good-quality paper, ideally 100% cotton. It may take you a while to find your own favourite, so try buying individual sheets of a few good name brands. Some retailers even offer variety packs of individual sheets across a selection of brands for this exact reason. Once you find a paper you like, I suggest you use the gummed blocks (pictured) for ease and simplicity. These are made up of multiple sheets glued around the edges to create a block. There is a small gap to run a palette knife around the edge, so once you finish a painting on the top sheet, you simply take the sheet off, and are ready to start your next painting.

MASKING TAPE

Using gummed blocks of paper means no stretching or taping of paper is required. If you are using individual sheets you will need to secure them onto a wooden board using masking tape. Once removed, the tape leaves an attractive white border to your painting, immediately giving it a more finished look.
Any low-tack masking tape will do: it does not need to be art-specific or expensive in order to work well.
Always remove the tape by pulling it away from painting - you only have to make the mistake of ripping into the painting once!

A PENCIL, SHARPENER AND ERASER

You'll see throughout this book that I begin with a pencil sketch before laying down any paint. Although a standard HB pencil is perfectly fine to use, I prefer a hard pencil (labelled with 2H or 4H), as these are usually a bit lighter in colour.
Along with this, you'll need a nice white eraser (I've used Staedtler since I was at school!) to correct any mistakes, and a pencil sharpener to keep your pencil lines nice and fine.

WATER POT

For these smaller paintings and the style of painting in this book, we do not need a lot of water – a mug will suffice, though a bigger pot of water is better, as it means you won't need to replace it as often.
Some people like to use one pot for cleaning brushes and another clean water pot for adding to their mixes. This can work well, but for me in the throes of a painting, this goes right out the window, so the simplicity of one large pot suits me much better.
More than anything else, the important thing is to keep your water clean – muddy water will lead to muddy mixes.

Techniques and tips

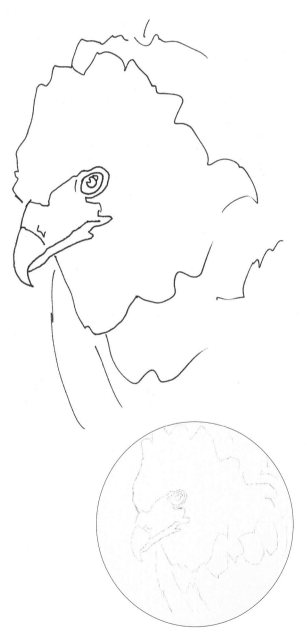

DRAWING

The outlines in the book are not drawn at actual size, but instead are there to give you reference of the shapes to copy. Your paintings can be any size you wish.

If you just want to get stuck into painting, or are uncertain about freehand drawing, that's fine – you can download the outlines at full size from Bookmarked (www.bookmarkedhub.com). Search for this book by title or ISBN: the outlines can be found under 'Book Extras'. All you need do is print them off and transfer or copy them onto your watercolour paper.

If you prefer to copy it across yourself, your watchwords for your initial drawing are 'simple, yet accurate.' Consider how you want the final painting to look, and where possible, leave out any detail you think you can do without – so rather than individual feathers, look for groups, as shown in the example here.

Start with big simple shapes: look for the proportion of the shape, the angle of the shape, and the alignment of the shape in relation to the others.

Draw lightly – once the paint's on top, you can't easily rub out the image. The lower image here is about as strong as you want it to look before you begin: clear enough to see, but faint enough to be almost lost in the finished painting.

Remember that you can always refer back to the image in the book if you're unsure during painting.

PAINT CONSISTENCY

You need to dilute your paint with water to make it flow – and the proportion of water to paint is really important. Throughout this book I refer to four consistencies: thick, creamy, milky and watery. The names give you an idea of how thick each should be.

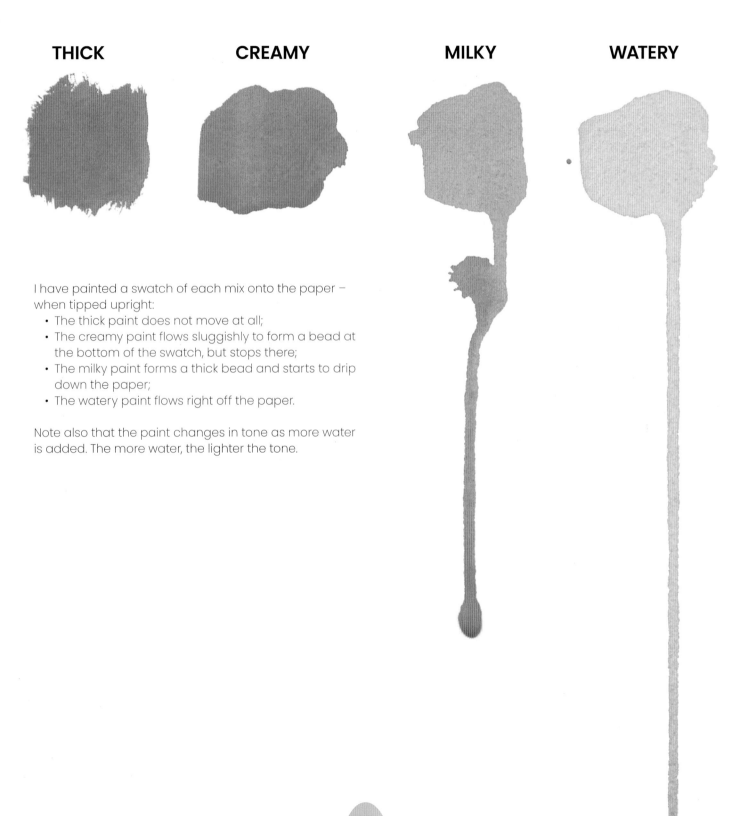

THICK

CREAMY

MILKY

WATERY

I have painted a swatch of each mix onto the paper – when tipped upright:
- The thick paint does not move at all;
- The creamy paint flows sluggishly to form a bead at the bottom of the swatch, but stops there;
- The milky paint forms a thick bead and starts to drip down the paper;
- The watery paint flows right off the paper.

Note also that the paint changes in tone as more water is added. The more water, the lighter the tone.

DRY BRUSHING

Despite the name, this technique relies on getting the consistency of the paint on the brush right as much as it does any lack of water. In fact, you don't want the brush bone dry, as this makes the brushstroke feel scratchy and awkward.

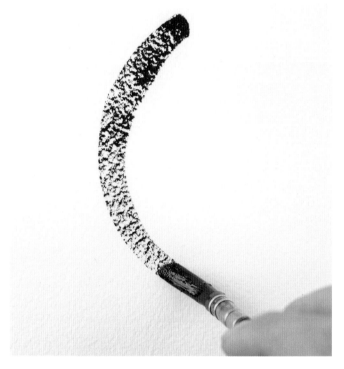

1 Prepare your paint to a thick, almost sticky consistency. Rinse the brush, then dry it on a piece of kitchen paper to take off the excess. When you draw the brush through the paint, you should feel a slight resistance.

2 Skim the brush lightly over the surface. The paint will catch and exaggerate the texture of the paper (called 'tooth'), leaving a slightly broken effect.

SPATTERING

At the other end of the viscosity scale from dry brushing, spattering relies on fluid paint. You don't want it too watery, however – the spattered droplets need enough pigment to make the right impact. For freer, looser spatters, simply hold the brush further from the paper – and if you want more control, hold it closer to the paper.

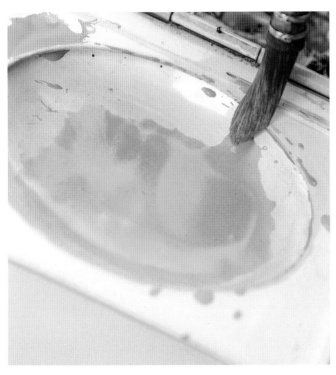

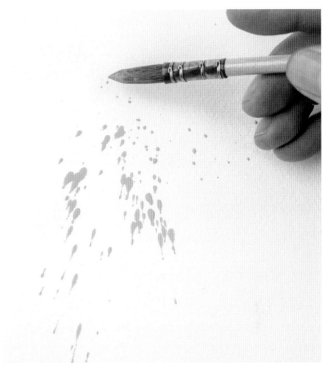

1 Prepare your paint to a milky consistency and heavily load the brush.

2 Hold the brush a short distance above the paper – around 5cm (2in) will give a good effect – and tap it firmly near the end of the ferrule with your finger to jog droplets of paint off the brush and onto the surface.

WET IN WET

Once the paint is mixed to the right consistency, you can apply it to the surface – and if you leave it to dry undisturbed you'll get a lovely flat, even result. We can play around with this, however, to create endless variation, by adding more wet paint into the wet paint on the surface.

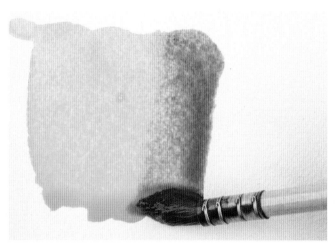

1 Paint a small block of new gamboge at a watery consistency, then rinse the brush. While the paint is still wet, load your brush with quinacridone red and add a stroke overlapping the yellow – the strokes will flow into each other and mix on the surface to make an orange.

2 While the paint remains wet, you can continue adding more colours, and they will continue to blend into one another.

3 Once it has dried, the colours form a smooth blend; great for suggesting gentle curves and soft shading.

The thicker the consistency of the paint, the less the colours will blend together – as you can see with this creamy consistency paint. Because the colours retain more of their identity, this consistency is great for suggesting more obvious angles or harder shapes.

DROPPING IN

This technique is useful at any stage; it's another method of getting colours to blend together, and is a really good way to suggest the texture of a bird's plumage quickly and without fussing. As with wet in wet, the consistency of the paint on the surface will help determine the results you get.

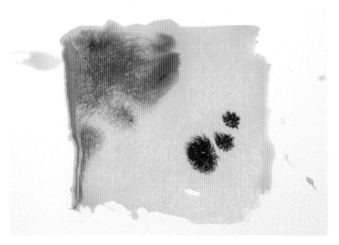

1 Paint a large pool of milky paint. Rinse the brush and load it with your second colour. Here I'm using a similarly milky consistency of red – note how the paint begins to run into the wet paint on the surface as soon as the tip of the brush makes contact.

2 Whereas the red and yellow have softened and blended together a lot, stronger consistencies, if left undisturbed, will dry in roughly the same area. Here I'm adding creamy blue – and you'll note that this consistency of paint doesn't mix or flow so readily.

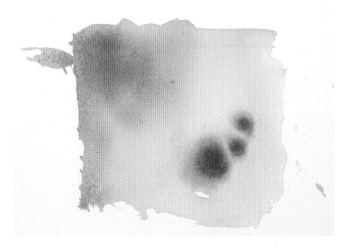

3 As long as it is left undisturbed, the paint will dry in roughly the same area – it will only soften in; it won't flow too far. This is great for soft markings.

SOFTENING EDGES WITH A DAMP BRUSH

This technique is perfect for softening the edges of marks and washes that feel a little too harsh or hard-edged. It's a great way to blend and soften marks and colours into their surroundings.

It takes a little practice to really get the feel of the wetness of the existing washes on the page and the level of dampness in the brush, but try this technique over and over on a couple of sheets of paper and you will soon have it added to your repertoire. You can then make it your own, using it wherever feels fitting.

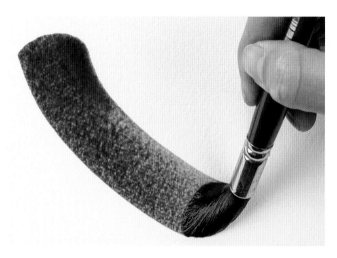

1 This technique only works if the paint is wet, so make a broad stroke. You can make it with any consistency of paint.

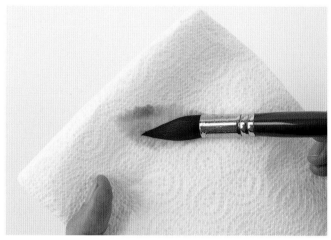

2 Rinse the brush and dry it on a piece of kitchen paper. Leave a little water in the brush. As a rule of thumb, the brush should end up just a little drier than the consistency of paint used for the stroke – if it's too wet, the flow of clean water will push the wet pigment away and you'll end up with a backrun or 'cauliflower'.

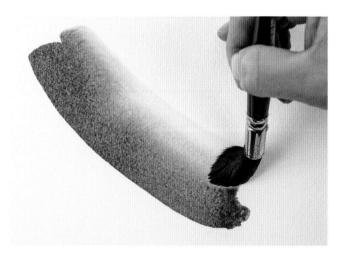

3 Draw the clean brush smoothly across the edge of the first brushstroke. The wet paint will flow into the clean stroke of water, softening the edge away.

4 You can repeat the process as many times as you need, until the paint has blended away completely. Be careful not to introduce too much water with each stroke, or work once the paint starts to dry. There's no need to rush, but if the paint is too dry, you'll end up with a stepped, streaky appearance like tidelines.

SUBDUING COLOUR

When painting birds, muted colours are important. Rather than using grey or brown paints, we can get exciting and varied muted colours by mixing the primaries together. Every colour has a complementary colour, and when the two are mixed, you will get a neutral hue. The complementary pairs are: blue/orange; red/green; and yellow/purple. 'But Tom,' I hear you say, 'we don't have orange, green and purple paints!' Don't worry. We can make these colours by mixing the other primaries – so if you need to mix an orange to mute your blue, you can make it by mixing any red paint with any yellow paint. Experiment to find the richest and most interesting neutral tones you can.

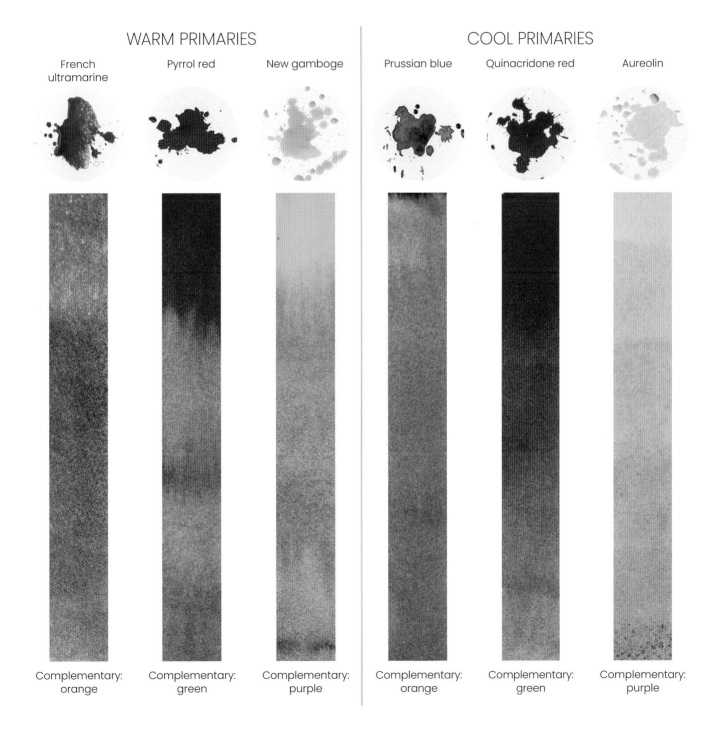

WARM PRIMARIES			COOL PRIMARIES		
French ultramarine	Pyrrol red	New gamboge	Prussian blue	Quinacridone red	Aureolin
Complementary: orange	Complementary: green	Complementary: purple	Complementary: orange	Complementary: green	Complementary: purple

HIGHLIGHTS IN EYES

With the eyes being such a prominent feature, and generally what we are drawn to most, it would be easy to think they must be painted with a lot of detail and are hard to paint. However, as you will see below, a very simple approach can provide all the life and character we need!

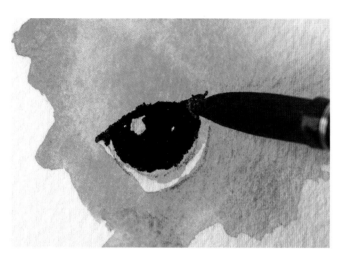

1 Start by filling in the shape of the eye using a dark neutral mix at a creamy consistency. Leave a small area of clean paper as a highlight at the top of the eye.

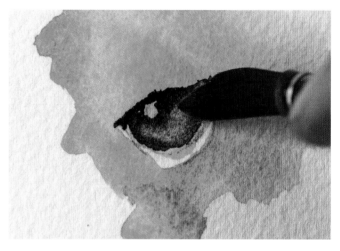

2 Rinse and dry the brush so it is clean but slightly damp. Draw the side of the brush in a crescent along the bottom half of the eye to lift out a little paint, giving a soft reflection.

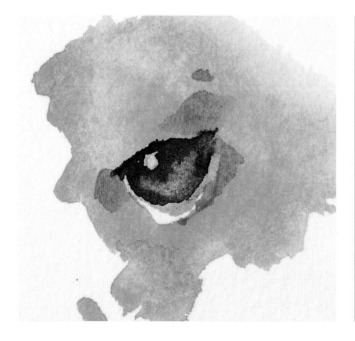

TIPS

• If you accidentally cover the white highlight, don't worry. Once the eye has dried, you can add a tiny dot of white gouache or titanium white as a highlight.

• The brush must be not too wet, nor too dry. If it is too wet, it will flood the dark and make a mess. If it is too dry, the brush will feel slightly sticky as you use it, and it will be harder to draw in a smooth crescent.

• Timing is a key component here. Pull the pigment out too soon, while it is still very wet, and the area will simply backfill with pigment. Leave it too late and you will not be able to pull any pigment out from the dry area.

TRAPPING THE LIGHT

It can be hard to create impact around very light-toned areas. This technique, sometimes called 'negative painting', allows you to frame the light area you want to throw forward. It's very useful, particularly for making sense of white plumage.

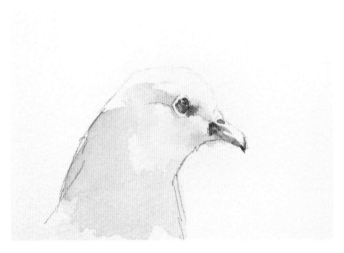

1 This dove is quite hard to make out, as the white feathers are the same as the white paper background.

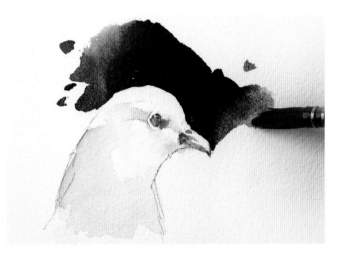

2 All you need to do is paint up to the edge of the bird with a darker mix. Loose, abstract marks work best.

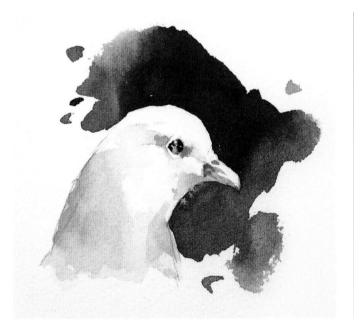

TIPS

• Don't outline the bird entirely – hinting at the shape while leaving something incomplete gives a fresh, lively finish.

• Remain conscious of the positive shape you are creating (the bird), rather than fixating on the background – it's easy to lose track of the fact we are carving out the shape of the bird at the same time. I find a useful way to work is using the brush tip to outline the bird before making larger marks and washes away from the bird.

• If you don't like the hard edges left by the loose marks of the background, use the softening technique on page 18.

The Projects

RAVEN

This project is all about getting familiar with paint consistency and its relationship to lightness and darkness – that is, tone. Rather than using black paint, which would give a dull, deadened result, we'll mix a simple grey from red and blue, and alter the tone by varying the amount of water we add – the more water, the lighter the result.

Focus on the wetness of the page and the thickness of your mixing while aiming to keep your marks simple, quick and fresh.

COLOURS

Prussian blue, pyrrol red.

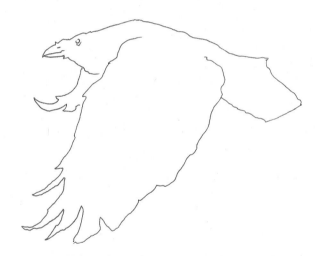

Outline drawing

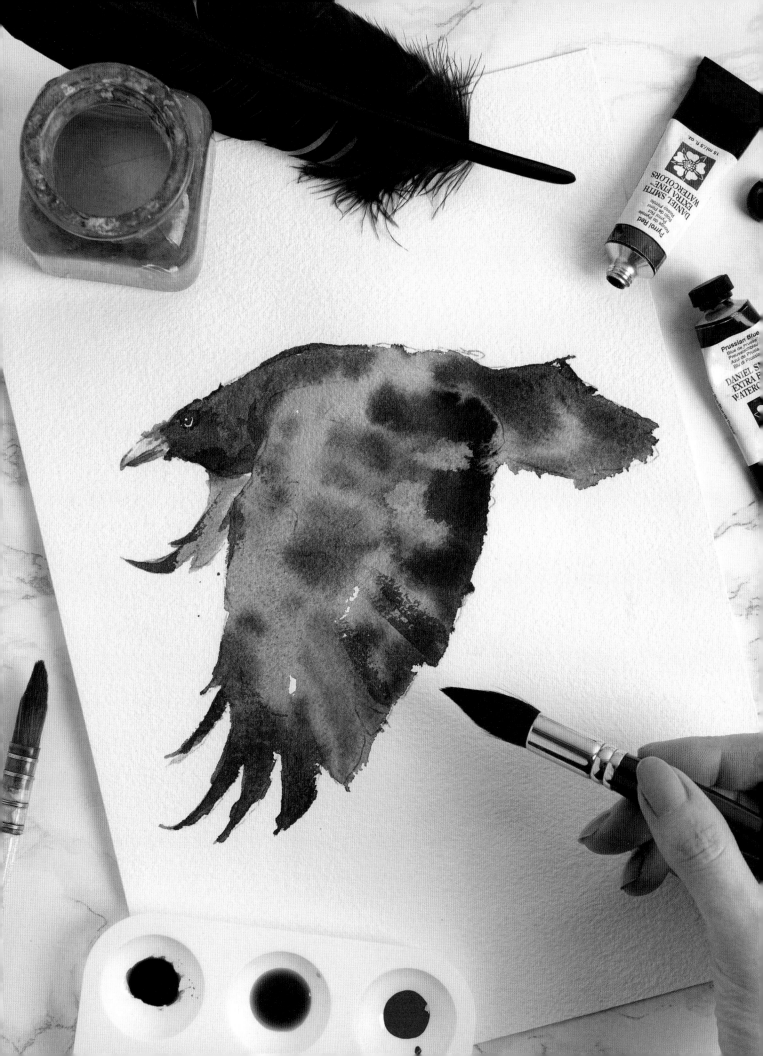

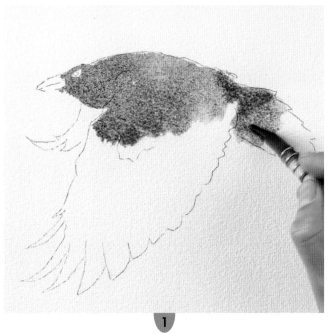

1

Using a watery mix of Prussian blue with a little pyrrol red, begin to paint the bird using a size 1 brush. Start at the top and work downwards.

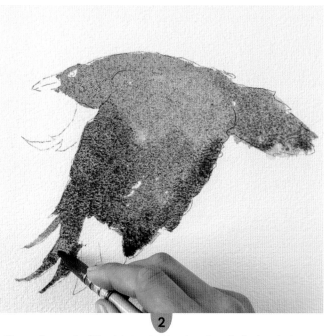

2

Cover the rest of the bird using broken brushstrokes to leave small gaps of white and rough edges to keep the result lively.

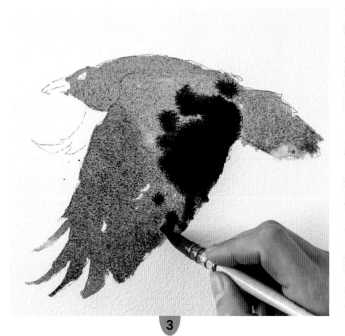

3

Make the mix a little creamier, by adding a little more of each colour, then begin to strengthen the depth of the colour behind the wing. Don't neaten it too much or you risk losing the sense of movement.

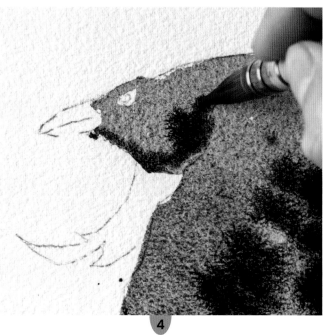

4

While the paint remains wet, develop the wingtips and shadow behind the neck in the same way.

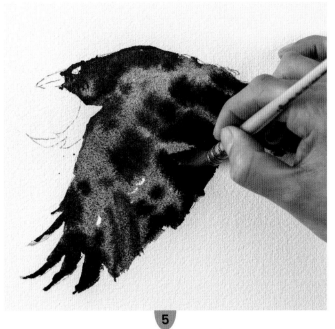

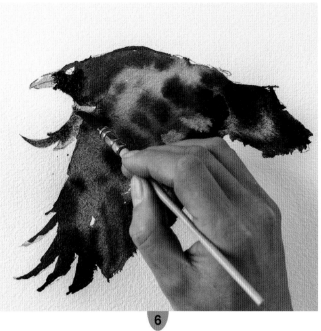

5

Draw a clean brush that's nearly dry (just a little water remaining in it) over areas that appear flat. This will lift out a little of the colour and help create a sense of form. Allow the paint to dry completely before continuing.

6

Once dry, use the more watery mix again to paint the beak. Use a smaller (size 3/0) brush to get into the finer spaces. Paint the more distant wing with the same brush and mix, then add some of the creamier mix wet-in-wet.

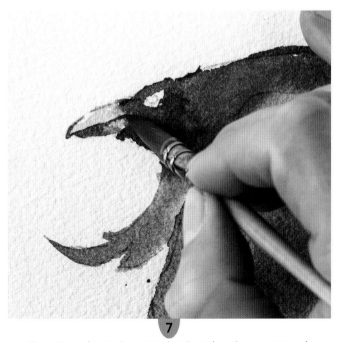

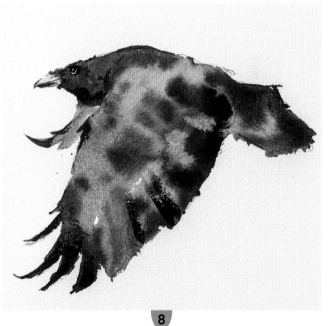

7

Allow the paint to dry completely. Using the creamy mix, strengthen the detail on the bottom of the beak with the tip of the size 000 brush.

8

Less is more with the finishing touches: use the tip of the brush to sharpen areas like the tips of the feathers on the wings, or to add texture to separate areas. Add the eye last.

BLACKBIRD

This is very similar to the raven in terms of techniques, but we're going to introduce a little eye-catching blast of colour, and a very simple background in the form of a freehand shadow.

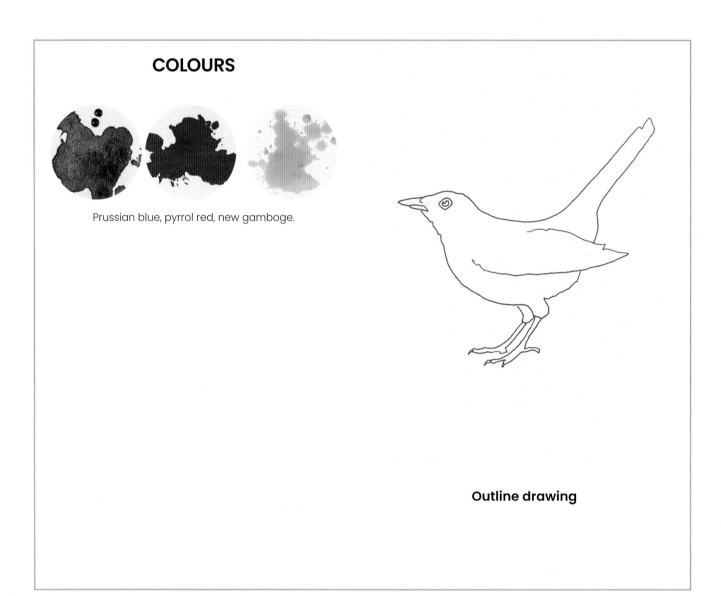

COLOURS

Prussian blue, pyrrol red, new gamboge.

Outline drawing

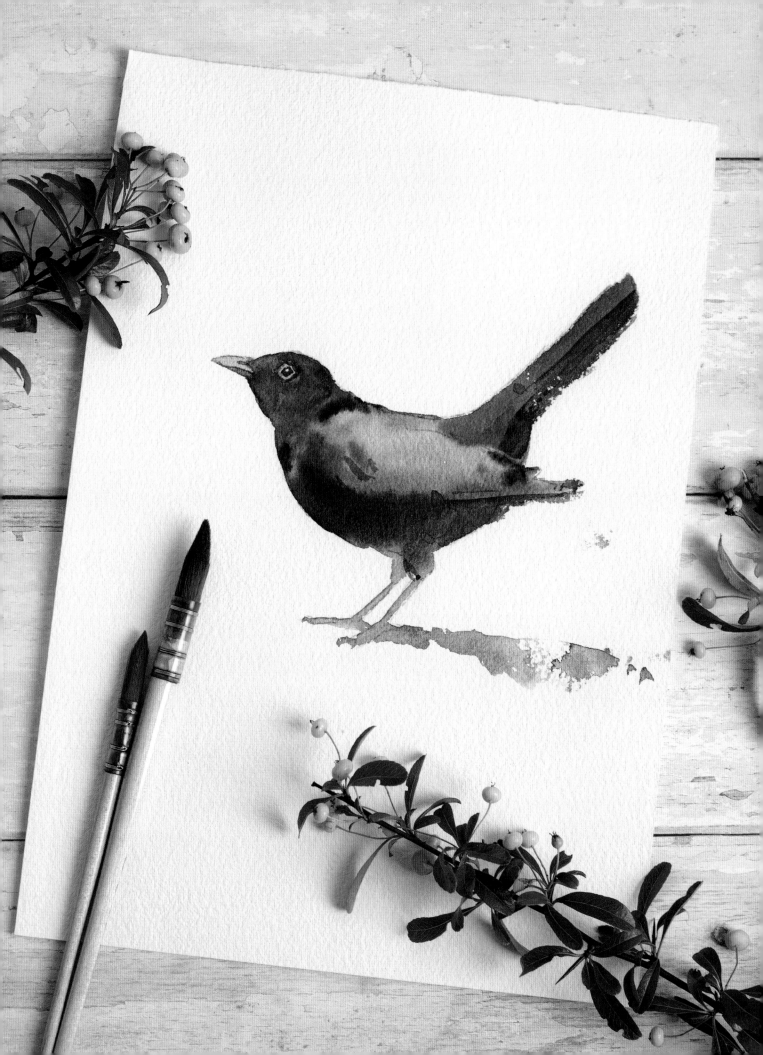

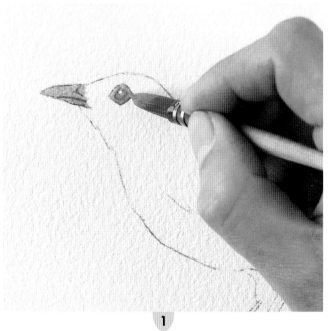

1

Make a milky mix of new gamboge with a hint of pyrrol red, and use the tip of the 3/0 brush to paint the beak and eye. Although it's only the eye ring we want yellow at the end, there's no harm in painting the whole eye (apart from a little spot of clean paper as a highlight), as the strong dark mix will cover it entirely.

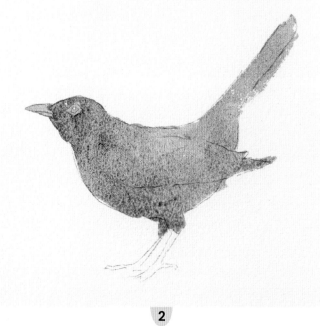

2

Once the yellow is absolutely bone dry, make a dilute dark mix of Prussian blue with a hint of pyrrol red. Use this and a size 1 brush to paint in the body of the blackbird, starting from the head and working back and downwards. Work more carefully around the eye, and more freely elsewhere, with bigger brushstrokes. Leave the legs and feet untouched.

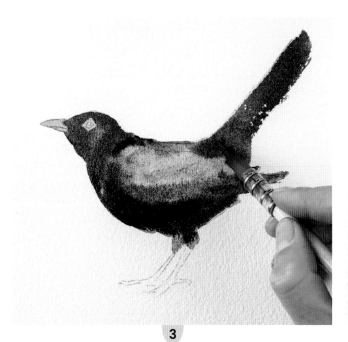

3

Add more paint to make the consistency creamier, then work wet-in-wet to develop the shadows. Don't be afraid to have a bit of a play with the paint – aim to suggest the shape of the blackbird with the shadows, leaving the lighter wash visible on top of the wings, for example.

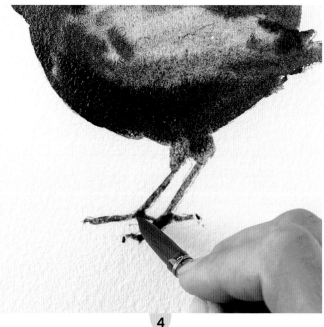

4

Add a touch more red to warm the mix, and carefully paint in the legs and feet. Keep these as simple as possible, by allowing the colour to flow, and applying as few brushstrokes as you can.

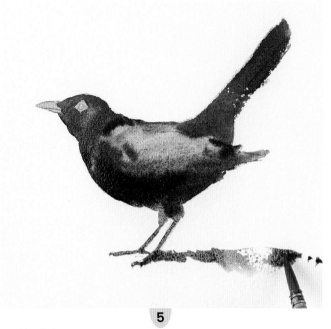

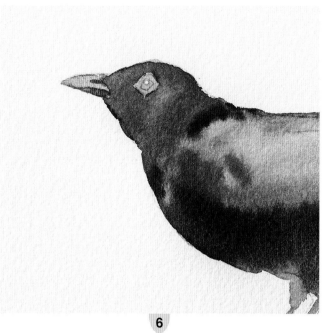

5

Add a little new gamboge to the dilute dark mix, and add a simple shadow with one bold, quick brushstroke leading out from the legs.

6

Allow to dry completely. Make a milky mix of new gamboge with a little more pyrrol red than before, and develop the detail on the beak.

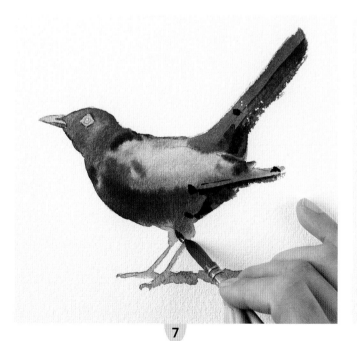

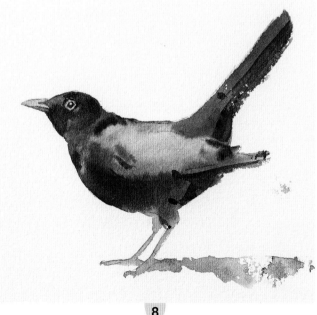

7

Use a creamy dark mix to add a few stronger, richer marks to suggest the deeper shadows beneath the wing and on the tail.

8

Leaving the clean paper highlight, pick out the black eye, then use thick paint and a nearly dry brush to flick on any final touches to bring your painting to life.

SWAN

Having tackled two black birds, let's take the opposite approach and paint a white swan. We'll learn how to trap the light.

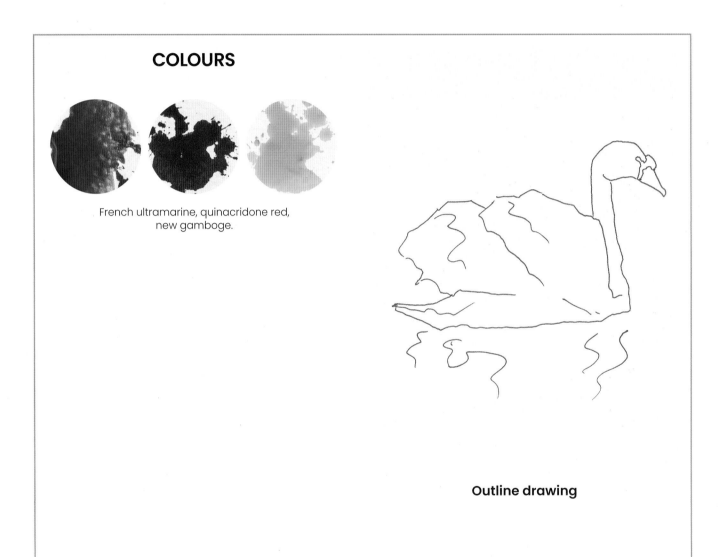

COLOURS

French ultramarine, quinacridone red, new gamboge.

Outline drawing

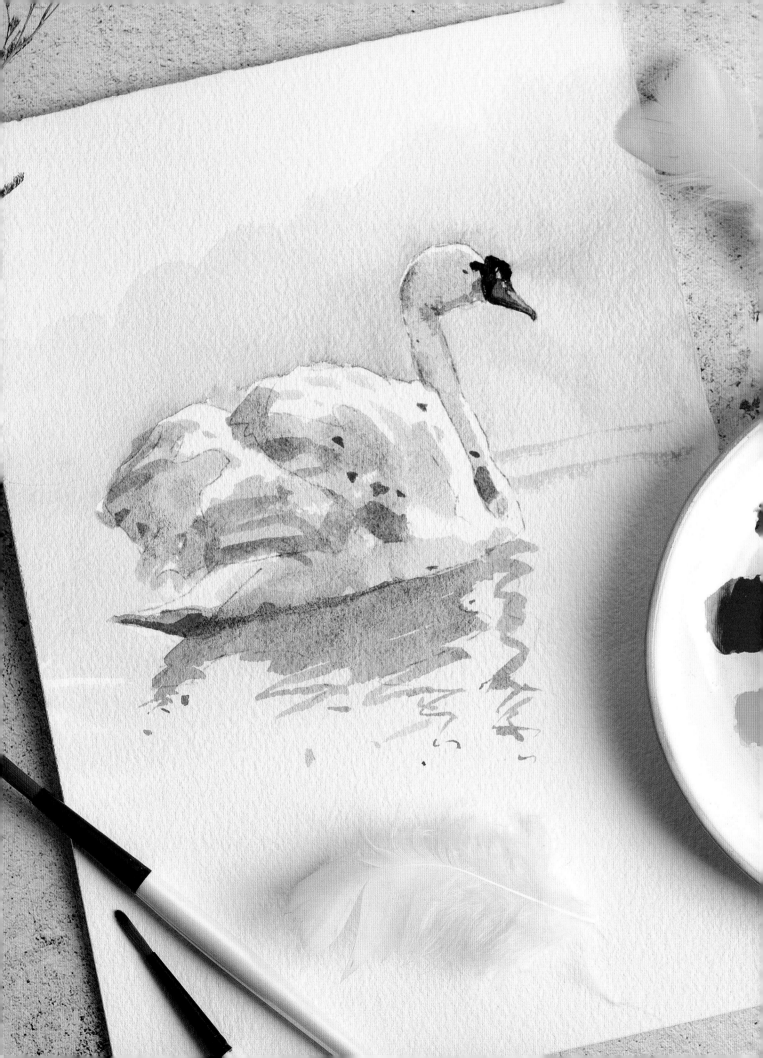

1

Block in the beak using new gamboge with a tiny touch of quinacridone red. Apply the paint at a fairly milky consistency, using the tip of the size 3/0 brush.

2

While the beak dries, prepare some French ultramarine to a milky consistency and paint the shadows. Leave the white of the page showing at the top of the head and keep the paint moving.

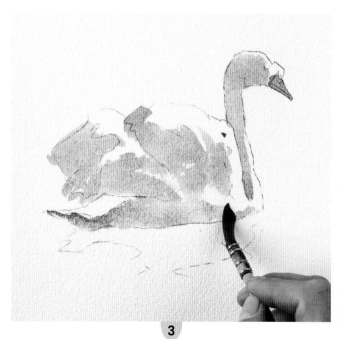

3

Continue building up the shadows, leaving the white of the paper as highlights. Try to link up the shadows to create a unified wash.

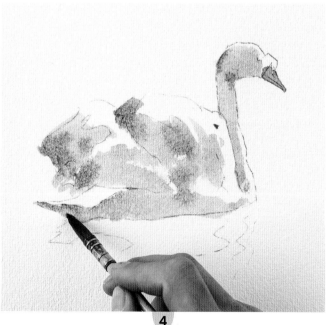

4

While still damp, strengthen the French ultramarine to a creamier mix and drop this into a few areas to increase the depth of colour in the shadows. Allow the paint to dry completely.

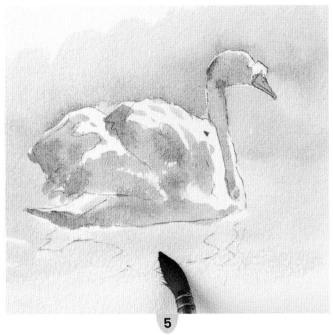

5

Make a dilute grey-green mix of French ultramarine and new gamboge. Use the larger brush (size 1) to paint around the swan, trapping the light on the bird itself by making the background just ever so slightly darker around it. Allow to dry.

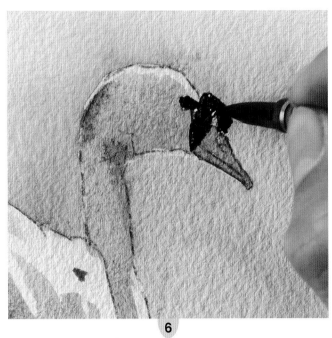

6

Swap to the size 3/0 brush and use a creamy dark mix of French ultramarine with touches of quinacridone red and new gamboge to develop the shaping around the beak and the eye. Aim to be simple, yet accurate.

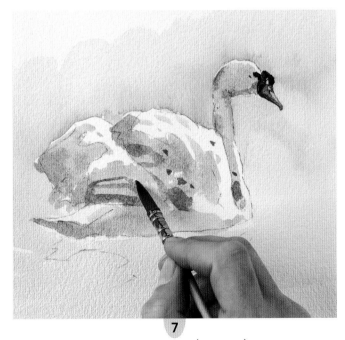

7

Strengthen the mix from step 1 (opposite) and add the shadow to the beak. Strengthen the shadows on the swan itself with creamier French ultramarine.

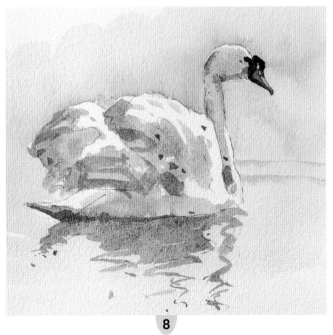

8

Mix a muted green by adding French ultramarine to the new gamboge (a tiny touch of quinacridone red will mute the mix further). Use this green mix to paint a very simple horizon line and some broken brushstrokes for a reflection in the water.

AVOCET

This project's a test of timing – if the paper's too wet, the black will bleed too much into the blue shadow, while if you leave things too late, you'll lose the lovely softness between areas. Don't worry if it doesn't work first time; practise and enjoy yourself while you get used to wet into wet.

This painting also gives us a good opportunity to 'trap the light' by painting a background up to the front of the bird.

COLOURS

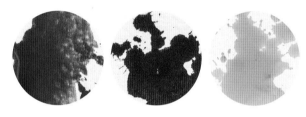

French ultramarine, quinacridone red, new gamboge.

Outline drawing

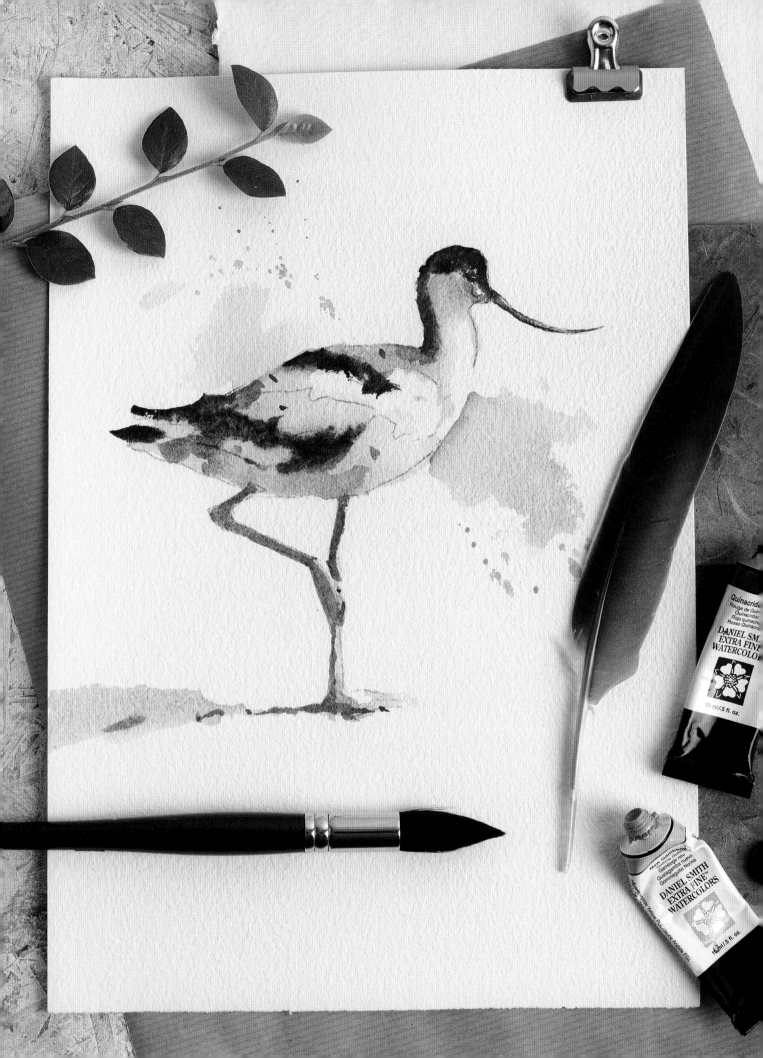

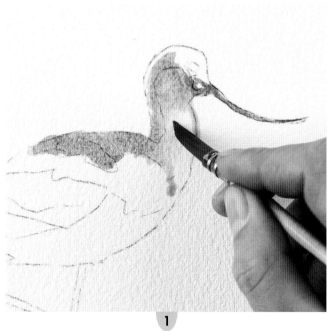

1

Use the size 3/0 brush to apply dilute French ultramarine to the beak and areas of shadow on the white as shown. We'll work in smaller areas at a time than before, to make it easier to assess how wet the surface is.

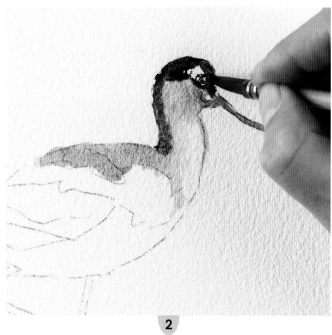

2

Look at the painting from an angle so you can see the light reflecting off the wet paint. Wait until the sheen softens – that's the right time to start painting the black areas with a dark, creamy mix of French ultramarine with a little quinacridone red and a touch of new gamboge. The paint should just creep into the blue shadow where it touches, but should not rush in and overwhelm it.

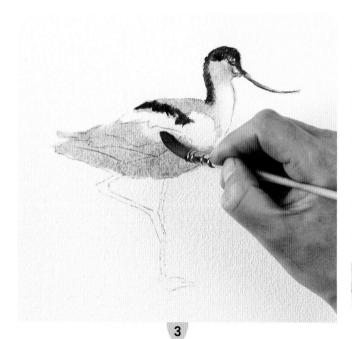

3

Swap to a larger size 1 brush and paint the remaining body of the bird with the same dilute French ultramarine used in step 1.

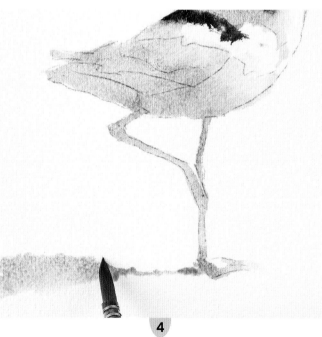

4

Working quickly – but not rushing – paint the legs with the same blue, then extend out a simple shadow to one side.

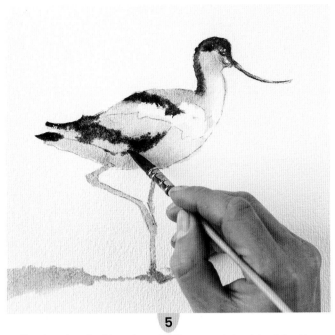

5

Still using the size 1 brush, paint the remaining black feathers with the same dark mix as earlier, and in the same way. Remember, watercolour is all about timing.

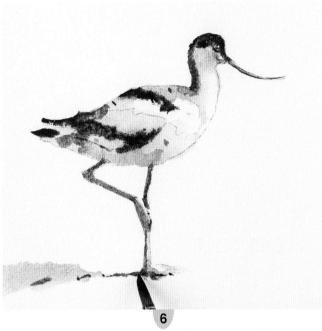

6

Allow the painting to dry completely, then add some punchy depth and detail to the shadows with creamy French ultramarine.

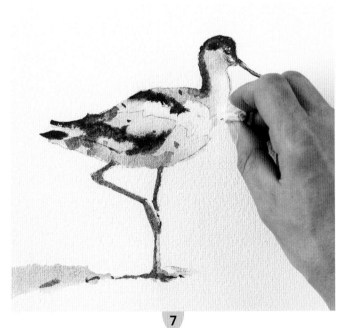

7

Add some shaping and detail to the legs and shadows with the same creamy dark mix. The painting's finished at this point, but if you want to push it a little further, use a putty eraser to gently remove the pencil lines near the front of the bird's breast.

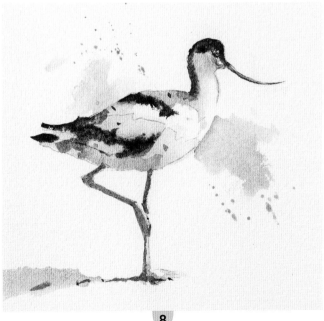

8

Add a simple painterly background with very loose marks of a milky mix of new gamboge with a hint of French ultramarine, applied with quick, light strokes of the size 1 round brush.

ROCKHOPPER PENGUINS

So far, we've just mixed the colours as we've needed them. For this project, where you'll need larger amounts to paint both birds, I suggest you prepare your colours and mixes in advance on your palette. This will mean you don't have to rush to get a particular colour ready, or to catch the wet paint at the right moment.

The key to the variegated wash technique introduced here is to leave the white spaces – this way the colours read as shadow.

COLOURS

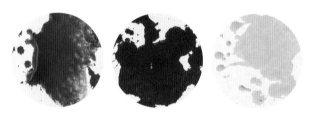

French ultramarine, quinacridone red, aureolin.

Outline drawing

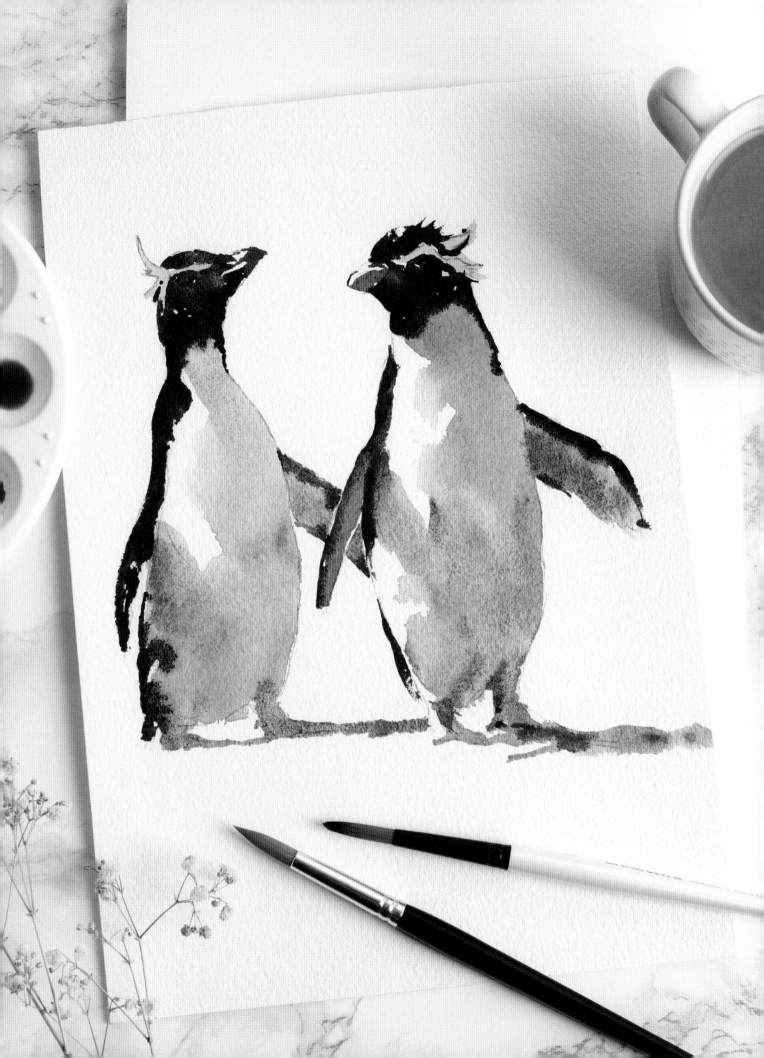

1

2

Using the size 3/0 brush and creamy quinacridone red, block in the eyes on both penguins. Do the same for the feathers on the head using creamy aureolin.

Prepare the following colours, all at a milky consistency: French ultramarine; quinacridone red; a purple mix of French ultramarine with a little quinacridone red; and an orange of aureolin with a little quinacridone red.

Start to paint the shadow on the left-hand penguin with a variegated wash. Start with French ultramarine at the top, then introduce the purple mix wet into wet.

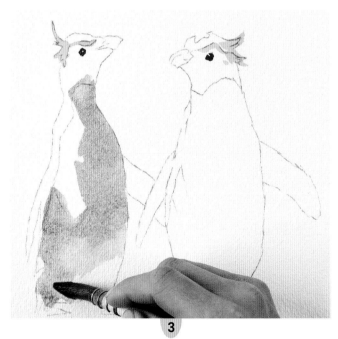

3

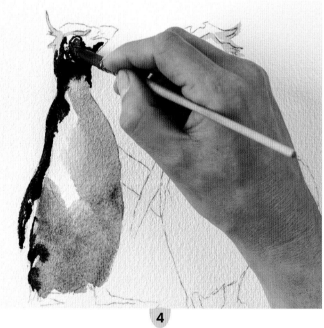

4

Continue to work down, adding the colours as you see fit, and leaving highlights of clean paper on the upper left-hand side. This is a good exercise in playing with colour. Aim for a variegated finish by softening some of the edges of light and shadow with a damp brush.

Using a creamy dark mix of French ultramarine, with a little quinacridone red and a touch of aureolin, paint in the dark feathers, letting the colour just bleed into the still-wet variegated wash.

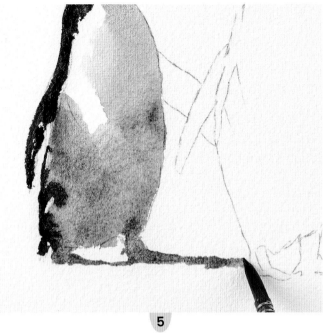

5

Paint the feet of the left-hand penguin with the milky French ultramarine, joining them together and drawing them to the left to suggest a shadow.

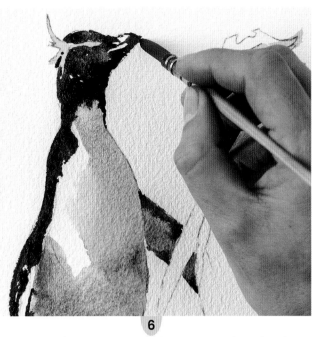

6

Paint the wing that connects the two penguins using the dark mix and French ultramarine, then add the beak with quinacridone red.

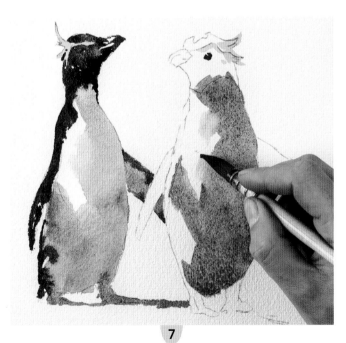

7

Once dry, follow steps 2–3 to paint the right-hand penguin. As you can see, the exact colours and placement you use aren't critical, so enjoy the process. Remember to leave an area of clean, dry paper on the upper left-hand area as highlights.

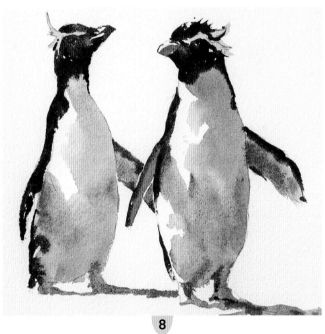

8

Continue to paint the right-hand penguin to finish. Leave a slight gap of clean white paper when you paint the overlapping wing. This helps to stop this area becoming confusing.

RED CARDINAL

Time to add a splash more colour with this punchy bird. Reds can go a little flat as they dry, so it's a good tip to start with a slightly orange mix to ensure red areas of your painting retain their warmth and strength once dry.

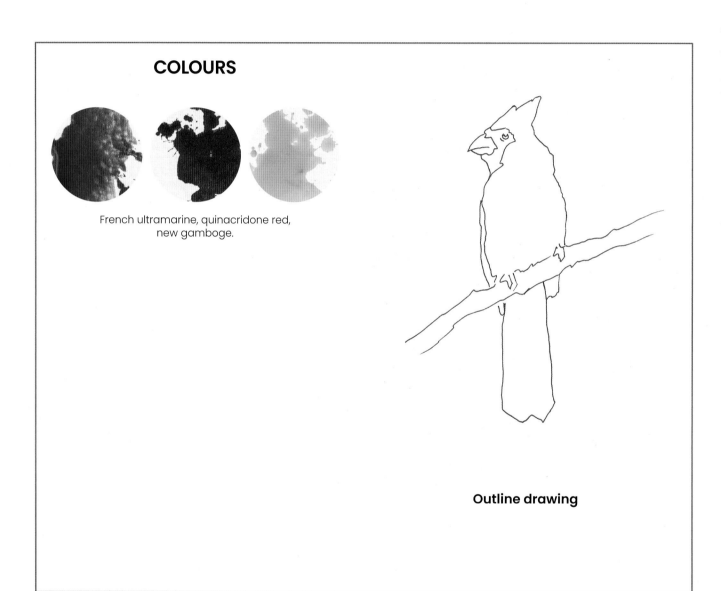

COLOURS

French ultramarine, quinacridone red, new gamboge.

Outline drawing

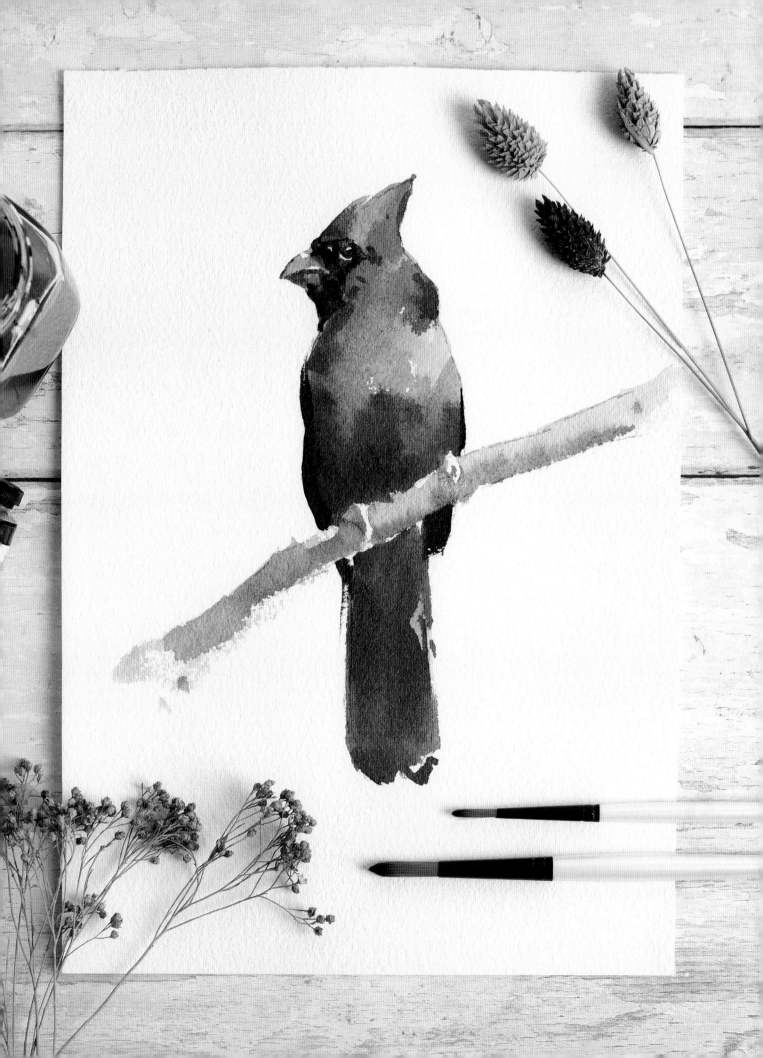

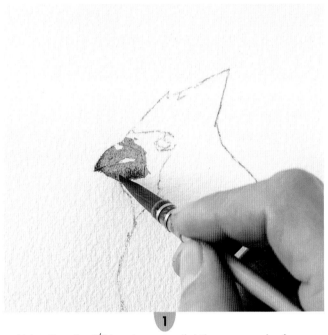

1

Using the size 3/0 brush, use a slightly orange mix of new gamboge with a tiny touch of quinacridone red to paint the beak. Add a slightly stronger mix wet in wet for the shadow at the base and bottom.

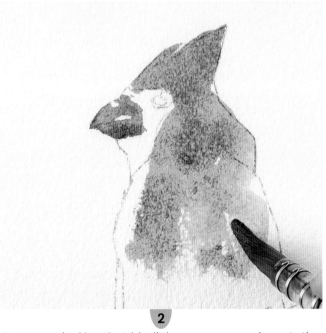

2

Swap to a size 1 brush. Add a little more new gamboge to the milky mix and start to paint the cardinal from the top down.

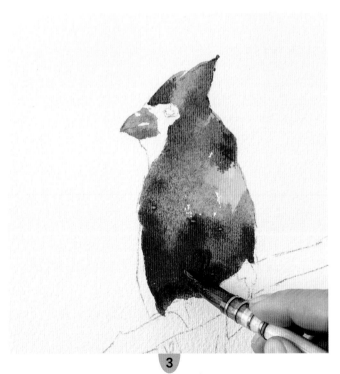

3

Introduce more quinacridone red to the mix as you work down. As you reach the branch, add a hint of French ultramarine to the mix for the area of shadow.

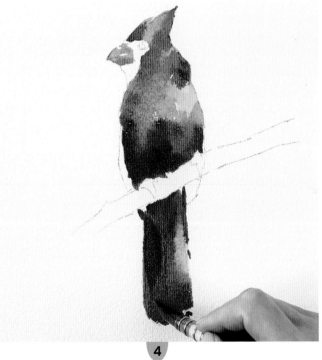

4

Paint the tail with quinacridone red with just a tiny touch of French ultramarine. If the mix looks too purple, you can add a touch of new gamboge. If you can paint it in just two or three bold brushstrokes, that's ideal.

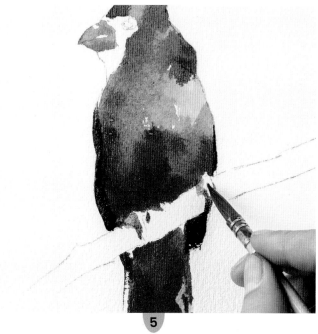

5

Make a thicker creamy dark mix of French ultramarine with a touch of quinacridone red, and use this deep purple mix to add some bold darks on the wings. Dilute this and add a hint of new gamboge to make a neutral dark mix for the feet.

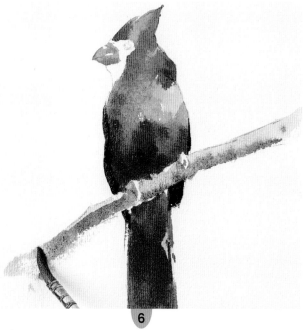

6

Paint the branch with loose strokes, using a dilute mix of new gamboge with a little quinacridone red and French ultramarine. Add a stronger mix of the same wet in wet for the shadow. Allow to dry completely.

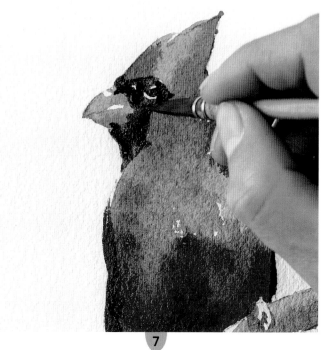

7

For the face, use a creamy neutral dark made from French ultramarine with a little each of quinacridone red and new gamboge. As it dries, use the tip of the 3/0 brush to drop in some even thicker spots of the same mix.

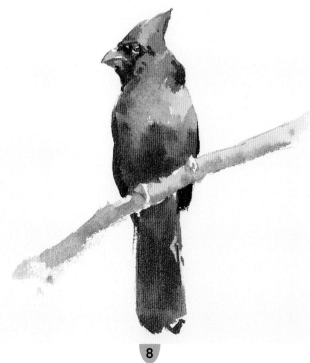

8

To finish, add some shaping and texture to the red areas with creamy quinacridone red.

FLAMINGO

As always with watercolour, it is the relationship between the wetness of the page and the thickness of the paint on your brush that is important – and that's what we'll explore here. Using thicker, creamier consistencies of paint will allow us to create wonderfully textured broken brush marks. Don't feel you have to create uniform perfectly 'filled-in' shapes. Watercolour is much more exciting and lively with a bit of texture.

COLOURS

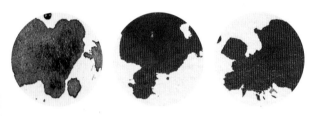

Prussian blue, quinacridone red, pyrrol red.

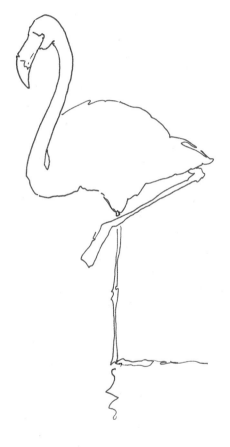

Outline drawing

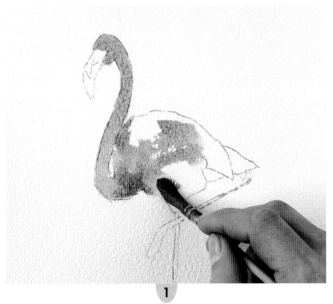

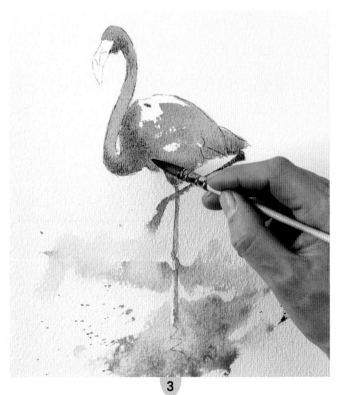

Use the size 3/0 brush to apply a first wash of watery quinacridone red. Be accurate with the head and neck shapes, and leave a few bits of white here and there. Leave the beak untouched.

Add a hint of Prussian blue for the legs, then use dilute Prussian blue on its own to hint at the water. Add some splashy, spattery marks.

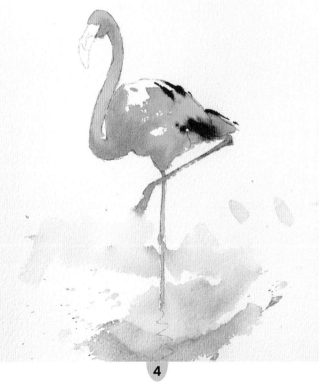

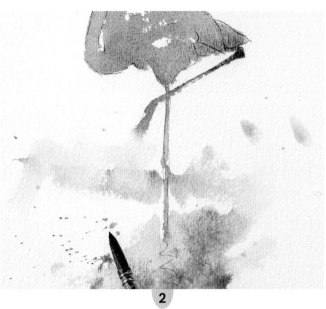

Use a creamier mix of quinacridone red with a touch of Prussian blue to build up the form of the flamingo.

While the pink is drying, drop in strong, thick pyrrol red to the wingtips. Take your time to create the accurate shapes of a few individual feathers. Allow to dry.

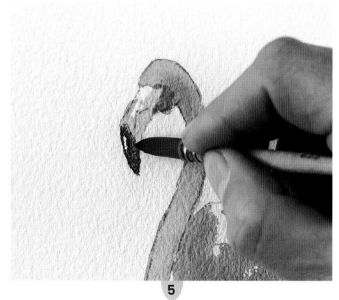

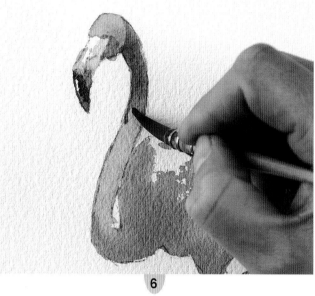

5

Paint the pink part of the beak with dilute quinacridone red. Use a damp brush with a hint of Prussian blue to add shadow on the face. Once dry, use a dark mix of Prussian blue with a little quinacridone red for the dark front part of the beak.

6

Strengthen the depth of tone and shadow on the neck with a milky mix of quinacridone red with a tinge of Prussian blue. Work down the body with the same mix to add shaping.

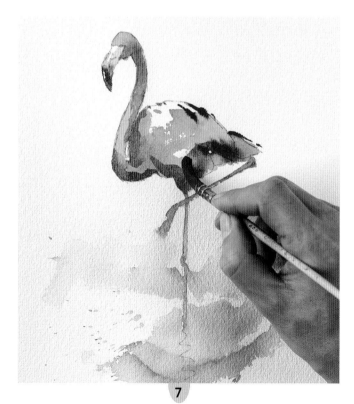

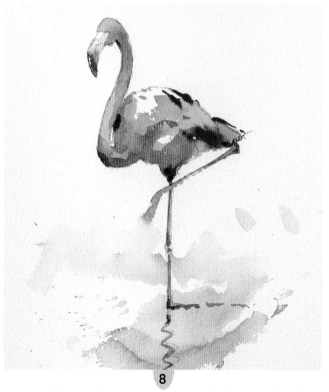

7

Push the colour a little darker with strong quinacridone red added wet in wet.

8

Use a stronger mix of quinacridone red with more Prussian blue to place a little wiggle for the reflection and a broken brushstroke for a touch of shadow on the water.

SCARLET IBIS

This project uses a lot of glazing – that's a technique where you paint the area, let it dry, then add more colour on top to enrich the underlying colour and deepen the tone.

COLOURS

Prussian blue, quinacridone red, aureolin.

Outline drawing

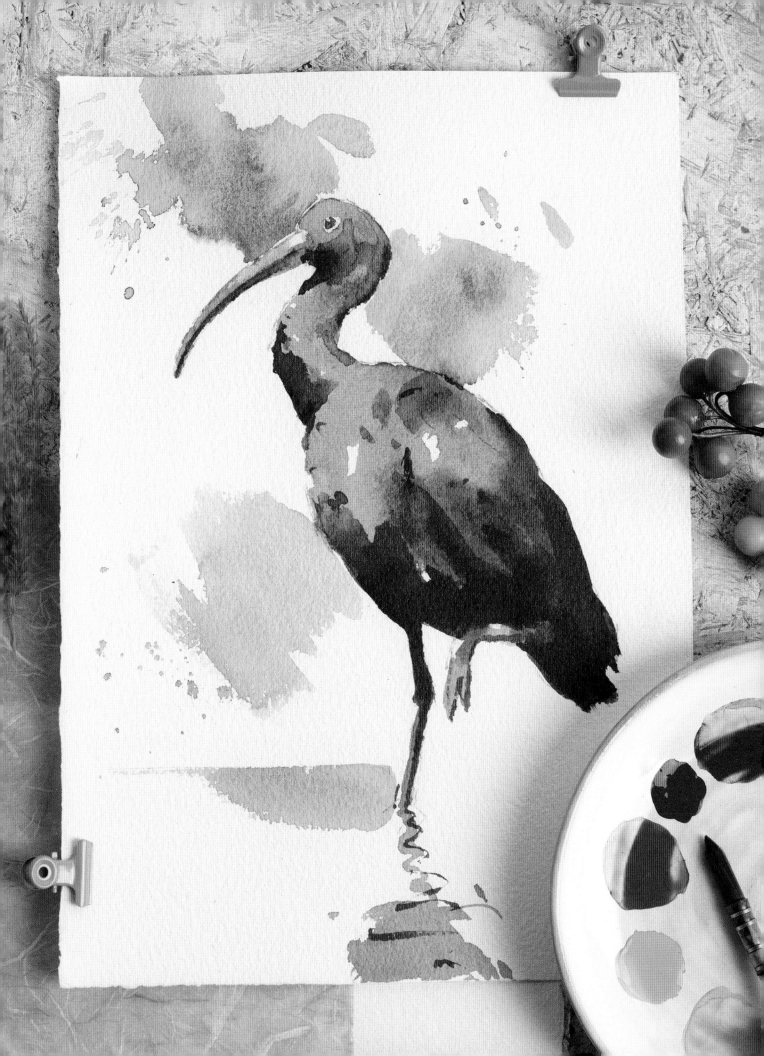

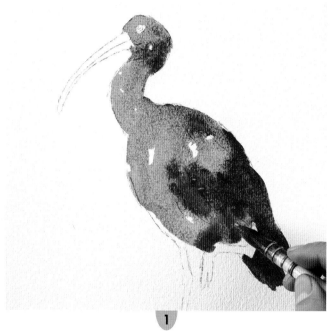

1

Make a milky mix of aureolin with a tiny touch of quinacridone red. Block in the ibis using the size 1 brush, leaving just a few white spaces for highlights. Try to work quickly, and add more quinacridone red in places to suggest the form of the bird.

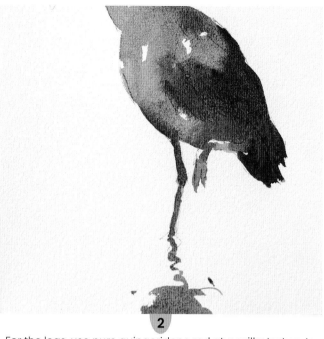

2

For the legs, use pure quinacridone red at a milky texture to give a pinker hue. Extend this down to the water's surface, then add some wiggly marks as a very simple reflection.

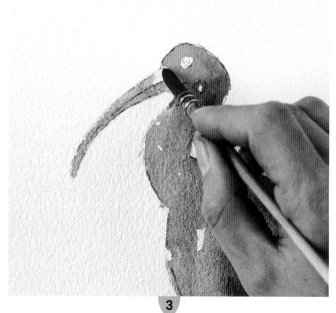

3

Allow to dry completely, then paint the beak using the point of the size 3/0 and a dilute mix of Prussian blue with a touch of quinacridone red and aureolin yellow. Start where the beak meets the head and carefully fill it in with a simple wash. Leave a little white highlight at the top.

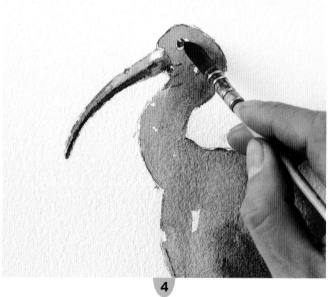

4

Add more Prussian blue to the mix and strengthen the tip and base of the beak as shown. Paint the eye with this stronger, bluer mix, again leaving a slight glint of clean white paper.

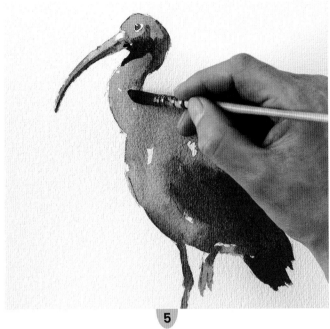

5

Still using the size 3/0 brush, prepare pure quinacridone red in a strong, creamy consistency. Use this to glaze the areas of shadow below the head and on the neck, using this strong mix to add shape to the neck. Rinse your brush and use the clean, damp hairs to soften the colour in slightly.

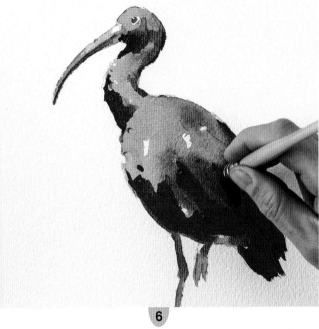

6

Continue developing the sense of the ibis' shape and form with creamy quinacridone red areas that you soften in with a clean, damp brush.

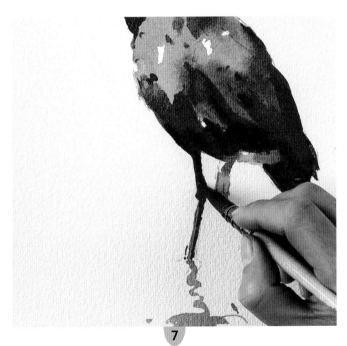

7

Continue glazing the legs, then add a little Prussian blue to the mix to darken it. Use this to work back into the darkest shadows on the ibis' body and legs. Allow the painting to dry.

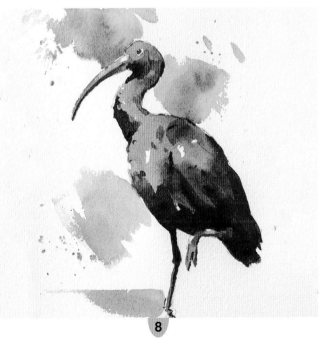

8

Add a touch of aureolin to Prussian blue to make a green. Use the size 1 brush to add a very loose, light and simple background with broad, sweeping strokes. Use spattering for the tiny marks – if you feel scared to do this, start a little lighter, then drop a slightly creamier mix into the spatters.

TOUCAN

For this project, we are pulling together all of the lessons from the previous ones to paint a black and white body with a colourful and interestingly shaped beak.

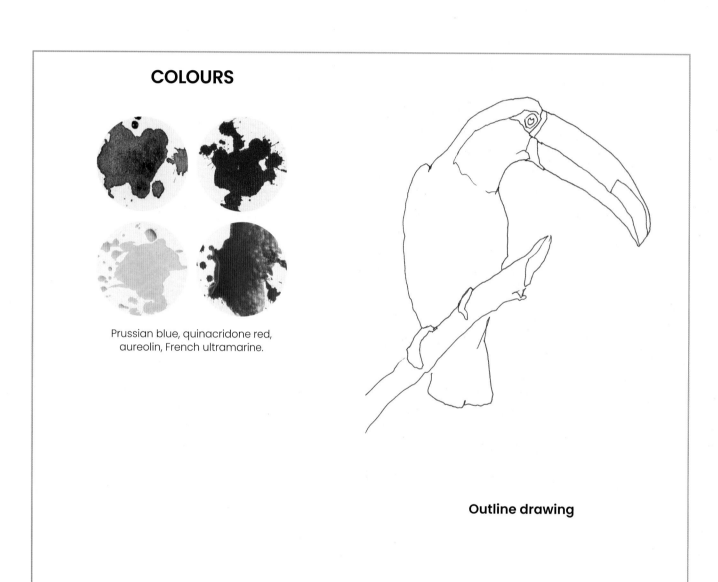

COLOURS

Prussian blue, quinacridone red, aureolin, French ultramarine.

Outline drawing

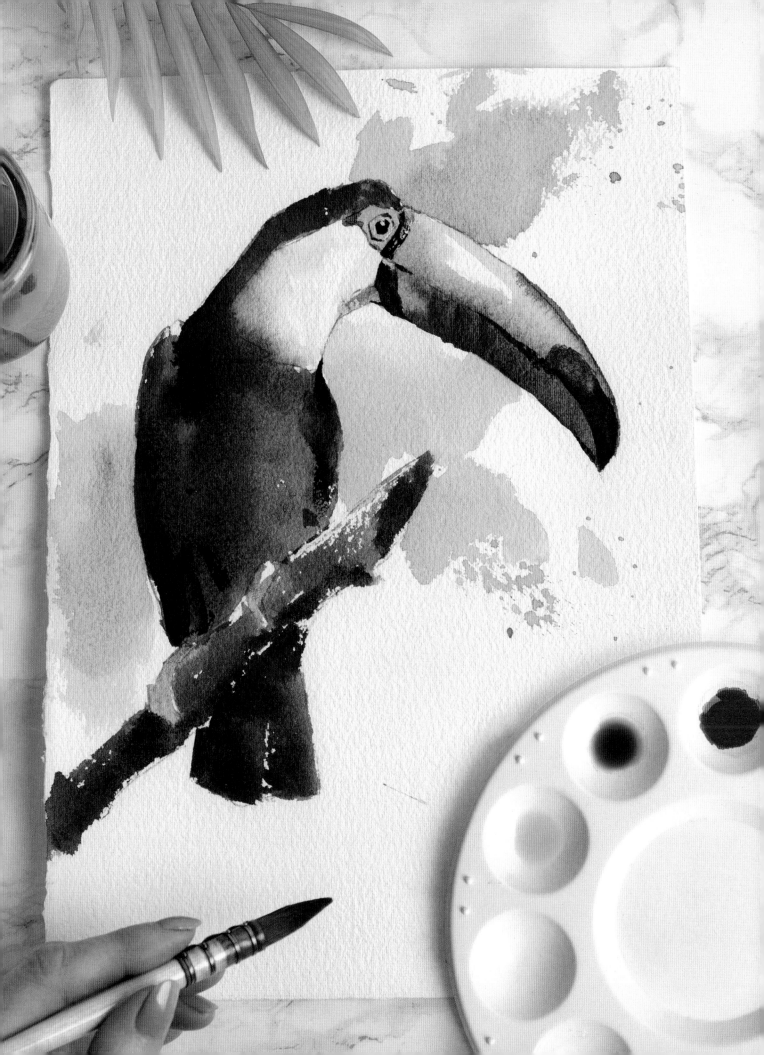

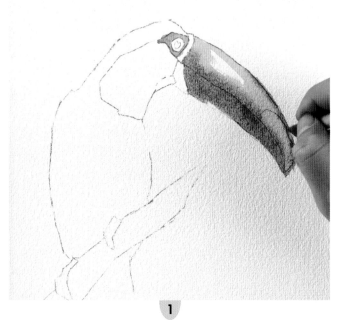

1

Use a size 3/0 brush to block in the eye ring with milky aureolin, slightly warmed with a touch of quinacridone red. Swap to a size 1 brush to block in the beak, leaving a highlight of clean white paper in the middle. Add a touch more red to add the orange shadows.

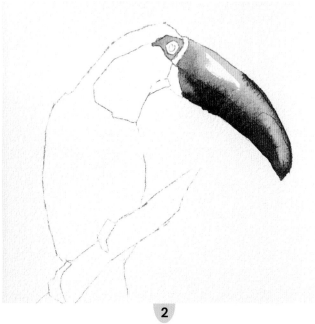

2

Working wet in wet, add more quinacridone red to the mix and strengthen the tone on the beak. Let the colour bleed slightly into the yellow. Add a little French ultramarine to the mix for the deeper warm shadows of the beak.

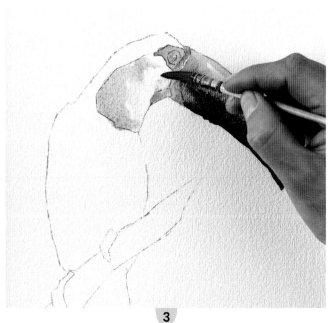

3

Once dry, use milky French ultramarine to paint the eye (leave a little clean paper highlight), the base of the beak and the shadow on the white feathers of the neck. Prevent any hard lines by softening the shadow with a clean damp brush.

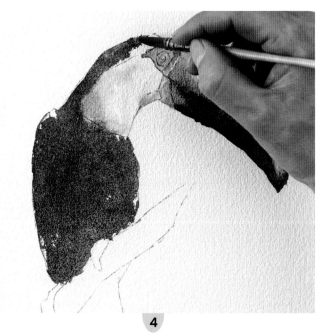

4

Swap to the size 1 brush and use a dark, creamy mix of Prussian blue with a little quinacridone red to lay in a wash over the black feathers of the toucan's back and head.

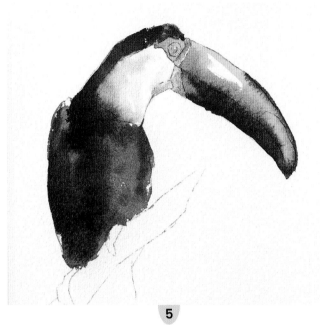

5

While still wet, make a rich, creamy dark mix of Prussian blue with a little quinacridone red and a little aureolin. Use this to develop the shape and tone of the black feathers.

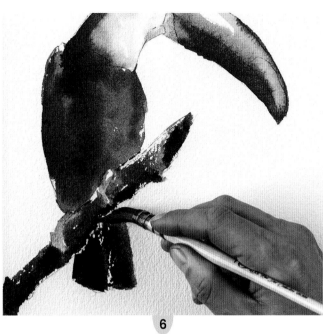

6

Paint the feet with milky French ultramarine; the branch with very simple strokes of a brown mix of quinacridone red and touches of Prussian blue and aureolin. Strengthen this for the shadow, then paint the tail with the dark creamy mix from step 4.

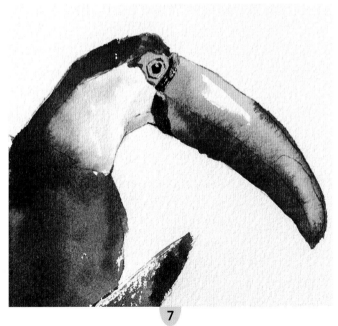

7

Use the same dark creamy mix to paint the eye with the tip of the size 3/0 brush. Make a neutral dark mix of quinacridone red, Prussian blue and aureolin and use it with a nearly dry brush to paint the darker parts of the base of the beak.

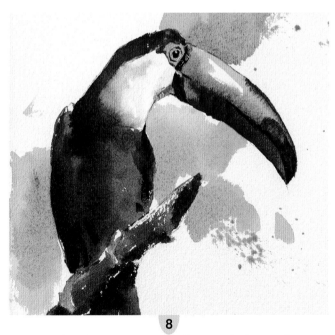

8

For the finishing touches, use milky French ultramarine on the beak markings, adding the deep creamy dark wet in wet. Add some short, broken marks along the split in the beak with the same mix: don't draw a single unbroken line. Add a simple background if you wish, using aureolin with a little Prussian blue. Add more Prussian blue for variety.

HUMMINGBIRD

In this project, we'll combine the variegated wash from the penguins with the controlled glazing we learned painting the ibis. As before, using clean, milky washes will allow the colours to merge. Once dry, small, simple shapes added over the top will bring the painting to life.

COLOURS

French ultramarine, Prussian blue, aureolin, quinacridone red.

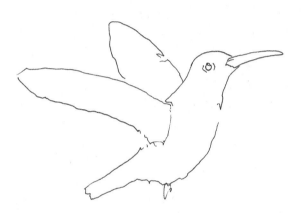

Outline drawing

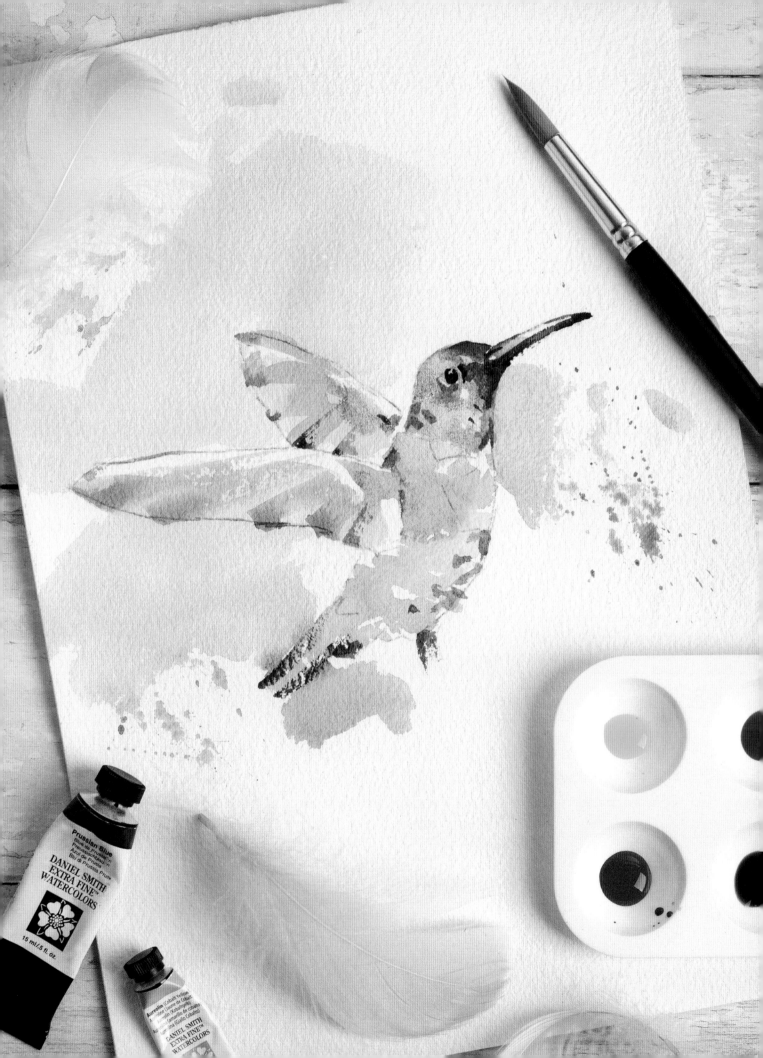

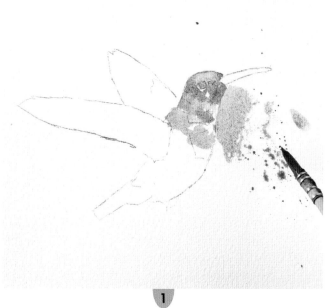

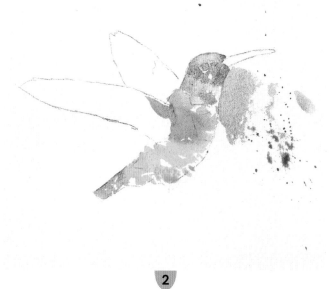

1

Prepare the following in milky consistencies: French ultramarine; Prussian blue; aureolin with a little Prussian blue (green); aureolin with a little quinacridone red (orange); and French ultramarine with quinacridone red (purple). Using the size 1 brush, start painting the top of the head with French ultramarine. Add Prussian blue below this, and break out into the background as shown.

2

Introduce the green mix below this, adding more water to the surface to let it bleed away into highlights, before adding the orange mix. Towards the tip of the tail, add a hint more quinacridone red to the mix. Leave plenty of white paper showing.

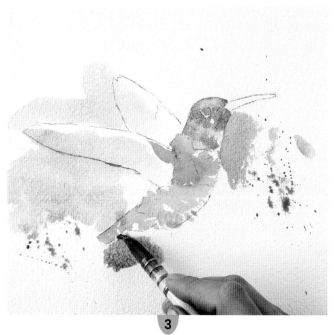

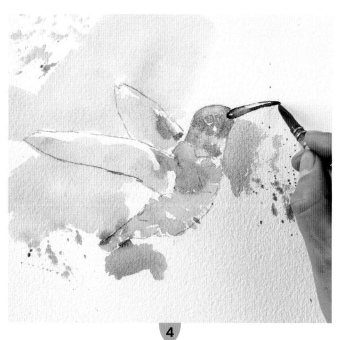

3

Use the purple mix to paint the wings and tail, leaving a white highlight at the top of each wing, before bringing the wash out into the background. Don't be scared – the darker colours added later will make sense of everything.

4

Once completely dry, use a size 3/0 brush to paint the lower beak with quinacridone red, then draw a fine red line over the top, leaving a white highlight. Darken the tip by adding a hint of French ultramarine.

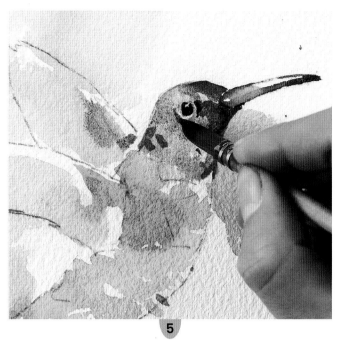

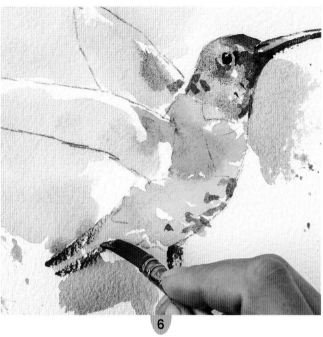

5

Use French ultramarine to hint at the texture of feathers on the head. It's much more effective to give the impression of feathers than to try to reproduce each one. Mix Prussian blue, quinacridone red and aureolin and use this dark mix for the eye, leaving our usual white highlight of clean paper.

6

Suggest the feather texture across the hummingbird by making a few marks with stronger versions of the earlier mixes. Add the feet with the purple mix.

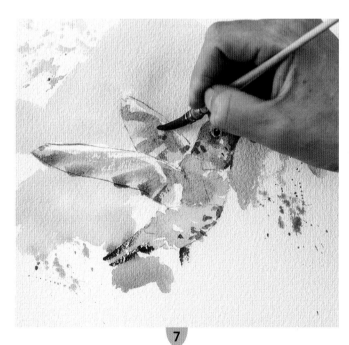

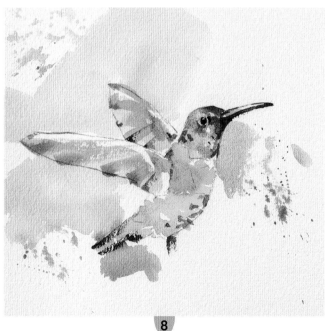

7

For the wings, add just a few bold, single strokes that start at the trailing edge of each wing and work inwards – this will give you a 'dry brush' mark that picks up the texture of the paper as it tapers away.

8

Add a couple of spattered marks to enliven the background.

LOVEBIRDS

We're going to keep going with lots of colour, working wet in wet and expanding the background. Always remember a few little details on top are what bring together the initial loose splashes!

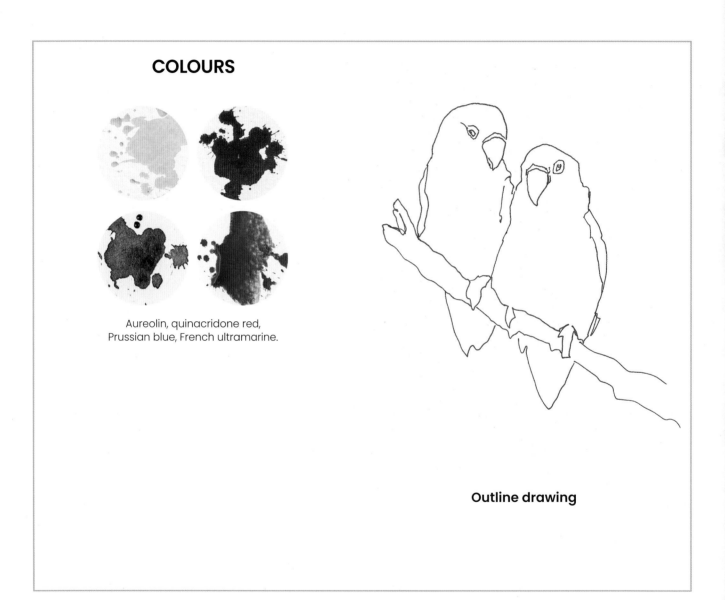

COLOURS

Aureolin, quinacridone red,
Prussian blue, French ultramarine.

Outline drawing

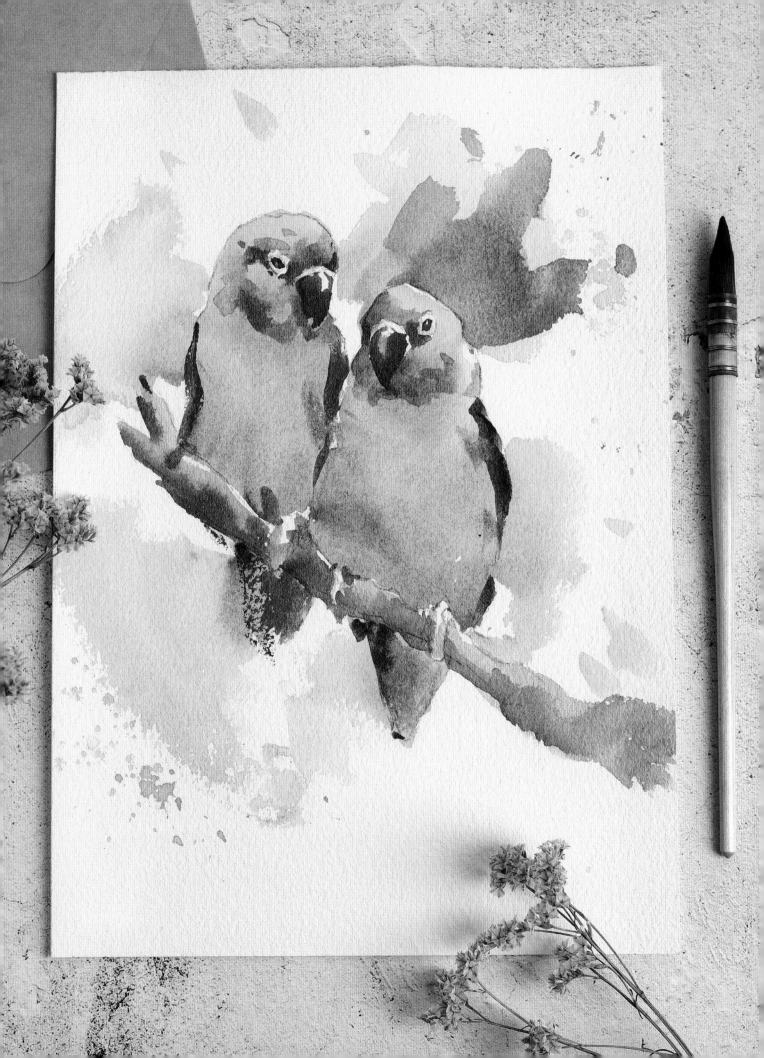

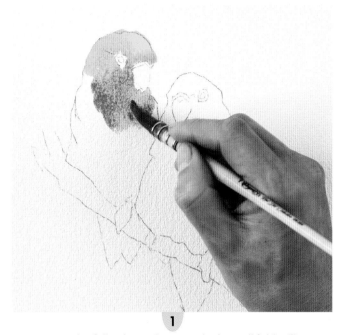

1

Prepare the following colours and mixes, all fairly dilute: aureolin; aureolin with a little quinacridone red (orange); aureolin with a hint of Prussian blue (green). Use a size 1 brush to start painting from the top of the head downwards. Start with aureolin, then introduce the orange mix in wet in wet.

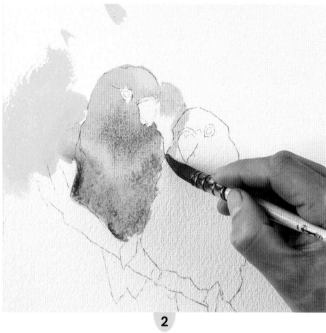

2

As you work down the left-hand bird, bring in the green mix down to the branch. Start to extend the colours out into the background – if you want to experiment, bear in mind that the background colours don't have to match the areas of the bird that they're near.

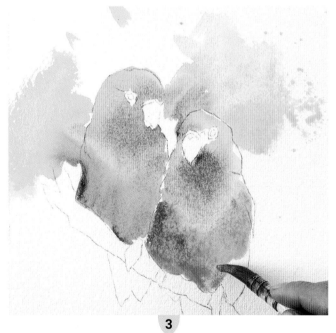

3

Add a few spatters and splashes here and there. Still working wet in wet, paint the right-hand lovebird in the same way as its companion.

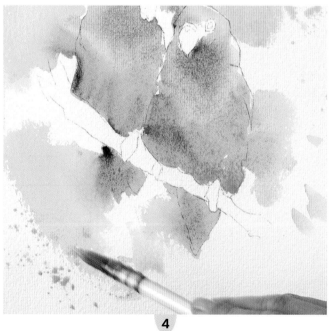

4

Paint the tails with green, then add some sweeping strokes in the background. Break this up with some spattering, then let the painting dry completely.

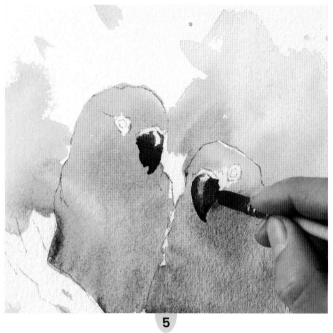

5

Use the size 3/0 to apply milky quinacridone red on the beaks, leaving highlights. Add a touch of Prussian blue to the mix and add this darker version wet in wet for shape and shadow.

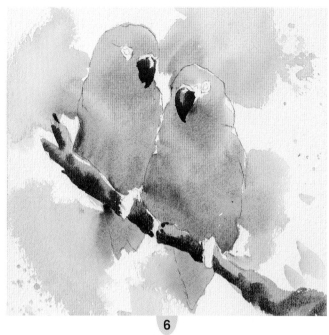

6

For the branch, swap to the size 1 brush and use a brown mix of aureolin, quinacridone red and a touch of Prussian blue. While it remains wet, strengthen the mix and add shadows at the bottom. Add more French ultramarine and dilute heavily; then use this grey-brown to touch in the feet.

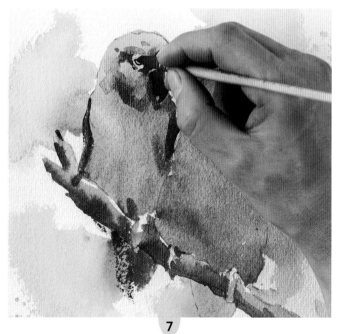

7

Using the same mixes as earlier, but with less water, begin to add definition to the left-hand bird with small glazes and the size 3/0 brush. Spend some time on the head, but the green area needs just a few marks for the wings and on the tail. Add the eye ring with very dilute grey-brown (see step 6). Once dry, paint the eye with Prussian blue with touches of quinacridone red and aureolin.

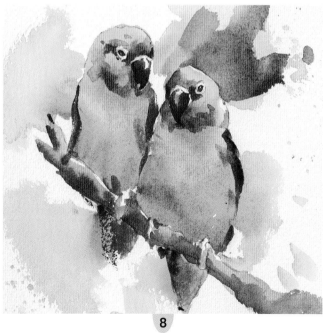

8

Paint the right-hand bird in the same way. As a finishing touch, trap the light by using glazes to strengthen the background colours around the birds.

BATELEUR EAGLE

This portrait-style painting allows us to take a much closer look at the details of the beak and eye. We will also introduce opaque paint to add life. To contrast with the details of the features, we will be working with lots of wet in wet for the surrounding feathers.

COLOURS

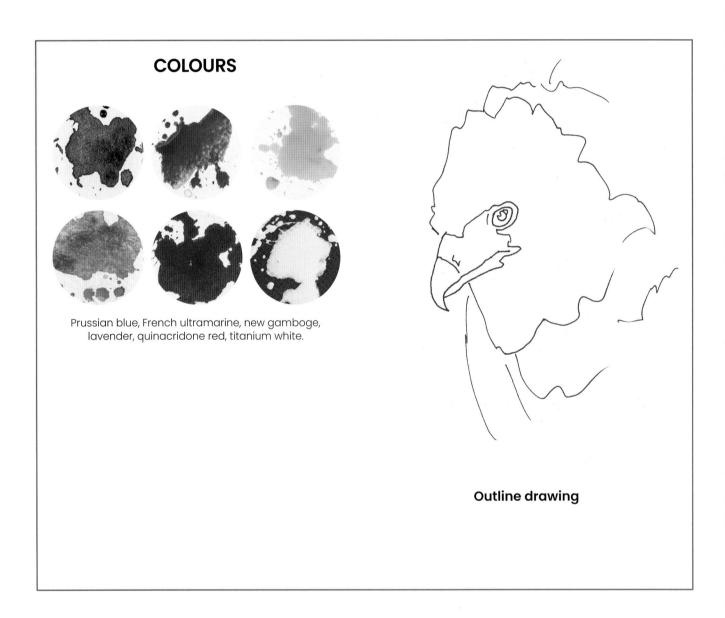

Prussian blue, French ultramarine, new gamboge, lavender, quinacridone red, titanium white.

Outline drawing

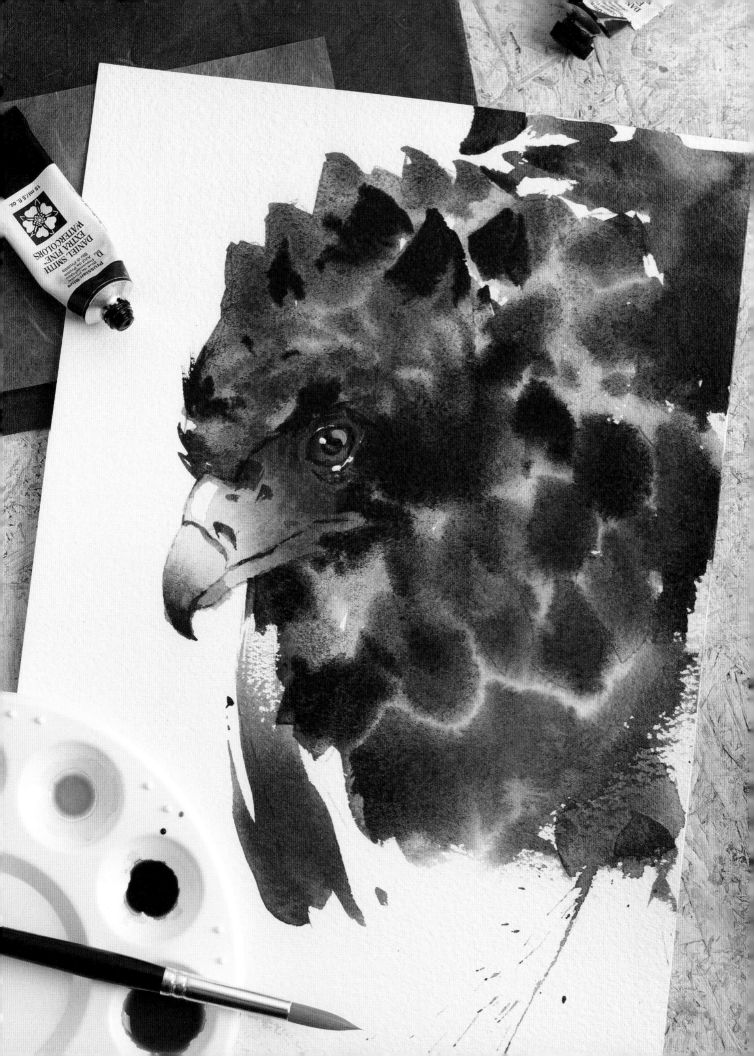

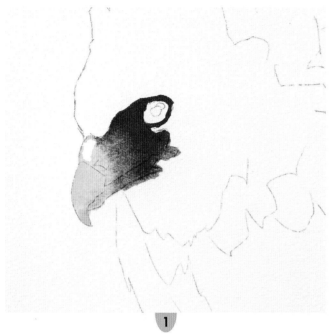

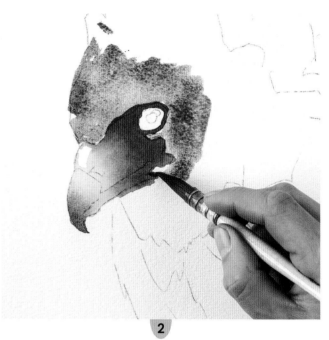

1

Use milky new gamboge to paint the front of the beak with the size 1 brush. Working wet in wet, add a hint of quinacridone red to the mix and blend the colour out. Continue adding more quinacridone red as you work towards the base of the beak, and use the tip of the brush to draw the red around the eye.

2

Working wet in wet, add the dark tip of the beak. Use a mix of French ultramarine with a little quinacridone red. The addition of red is important, as it stops the wet blue and yellow paint mixing into green on the surface. Once dry, use dilute French ultramarine to lay in a wash over the dark feathers. Use a size 1 brush near the features for more accuracy.

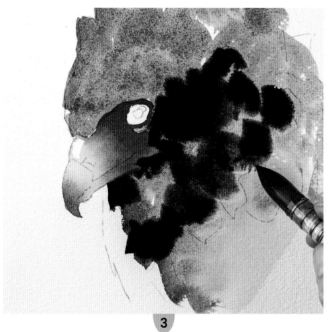

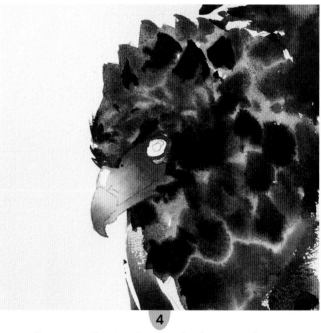

3

While still wet, swap to a very large six 6 brush to allow you to work quickly away from the features. Prepare a creamy dark mix of Prussian blue with quinacridone red and a little new gamboge and add it wet into wet with short, broad strokes.

4

Prepare a chestnut brown mix of new gamboge, quinacridone red with a tiny touch of French ultramarine to a milky consistency. Use this to add the warmer red feathers of the eagle's body with a few loose strokes.

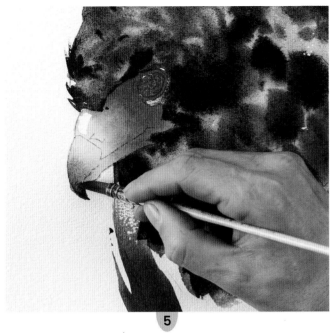

5

Switch to the size 3/0 brush and use the chestnut mix to develop the eye. Add more French ultramarine to the mix to darken and strengthen it, and work over the now-dry tip of the beak. Soften the colour away with a clean damp brush to avoid a hard line.

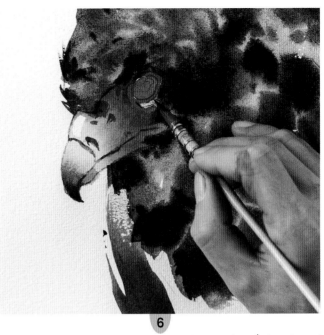

6

Bring in sharper details to the beak with the size 3/0 brush and creamy quinacridone red. Use a clean damp brush to soften the marks around the beak and face where necessary.

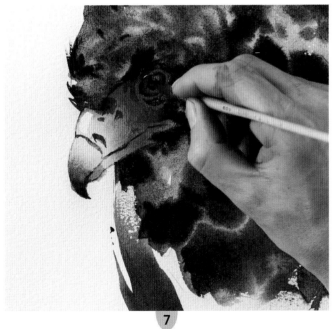

7

Make a creamy dark mix of quinacridone red with a little French ultramarine and new gamboge, and use this to add detail around the eye. Use a still darker, stronger mix of Prussian blue, quinacridone red and new gamboge for the eye itself.

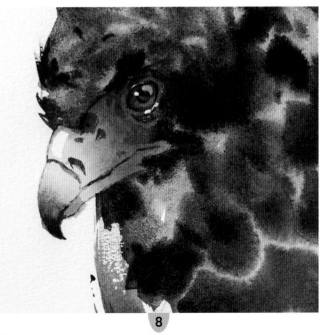

8

Once dry, add a semicircle highlight to the eye with lavender, and a couple of bright highlights with titanium white.

TAWNY OWL

This is another bird where markings can quickly overwhelm them. Keep your focus on free-flowing colours and lovely gradients underneath: think of the markings as decoration on top which can be added later.

Whether you keep it as simple as I have is up to you; you might choose to go a little further – the face can certainly handle a little more detail to draw the attention.

COLOURS

French ultramarine, Prussian blue, quinacridone red, new gamboge.

Outline drawing

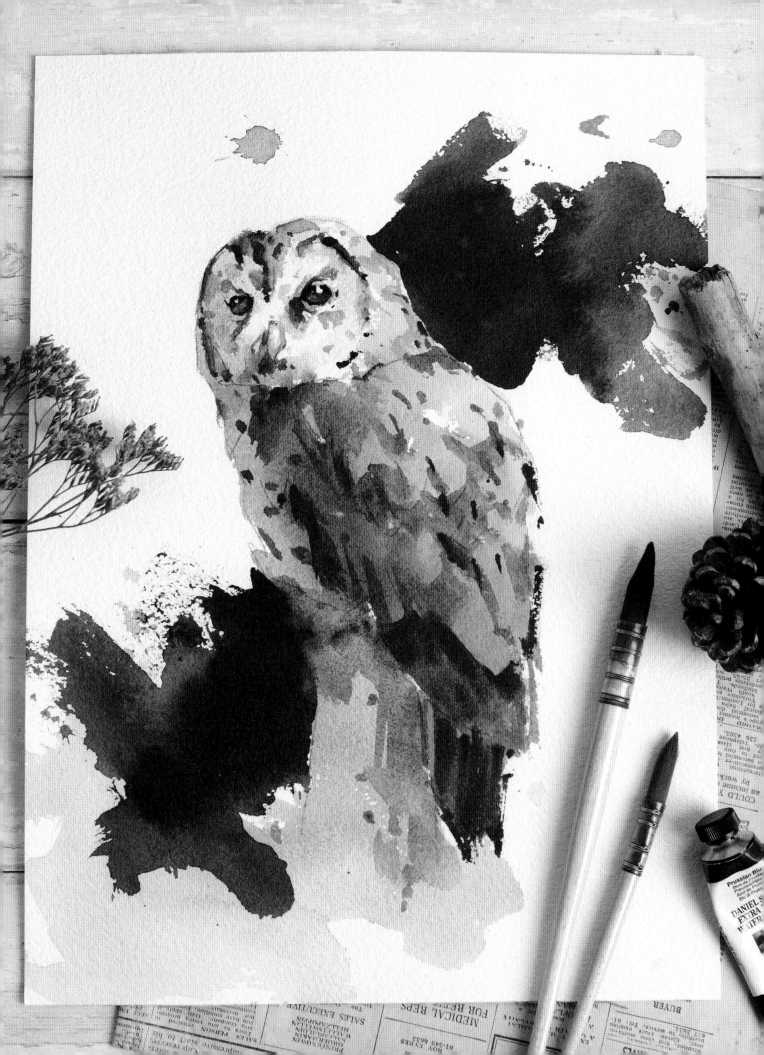

1

Using a size 1 brush, block in the shadow shapes of the face using milky French ultramarine, leaving a space in each for a highlight. Continue working down the body, adding a little quinacridone red.

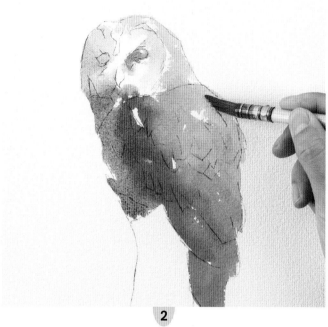

2

Combine new gamboge with quinacridone red and a touch of French ultramarine for a milky chestnut mix. Use this to block in the shadow on the back. As you move around to the side in the light, add more new gamboge and a little more water.

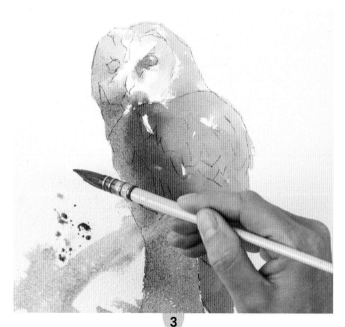

3

Make a milky grey-brown mix of all the primaries and paint in the stump on which the owl is perching. Use quite loose, vigorous strokes, and add a little spatter. Allow to dry completely.

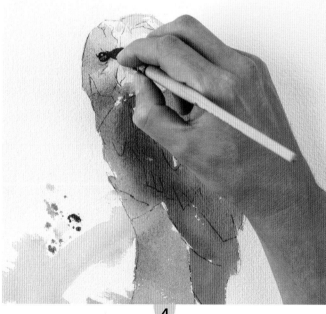

4

Still using the size 1 brush, add some detail to the face with a creamy mix of Prussian blue, quinacridone red and a little new gamboge. Block in the eye, leaving a little of the underlying paint as a highlight. Rinse and dry the brush and use it to lift out a highlight from the bottom of the eye.

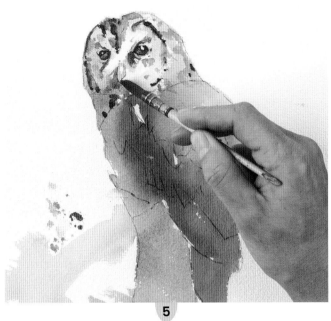

5

Paint the other eye in the same way, then make a creamy chestnut mix by combining new gamboge with quinacridone red and a touch of French ultramarine. Use this to add detail and markings around the face. Make sure these aren't too stark and harsh; if necessary, use a damp brush to soften them a little. Change to a size 3/0 brush and paint the beak using new gamboge at a milky consistency.

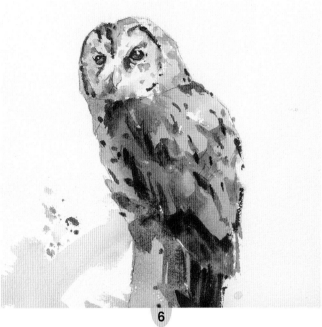

6

Using the same creamy chestnut mix as in step 5, use the size 1 brush to add simple shadow shapes to the owl's plumage. Strengthen the mix still further for the darker areas.

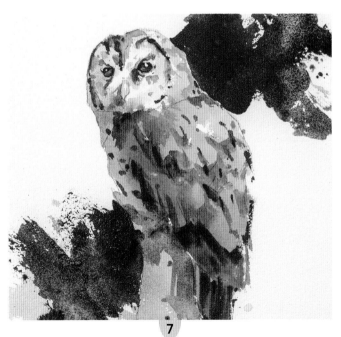

7

Make a well of milky French ultramarine, and use it to add shading to the stump with the size 1 brush. Make a creamy mix of Prussian blue with a little quinacridone red and new gamboge, and use this dark colour to work a little background out from the owl and stump.

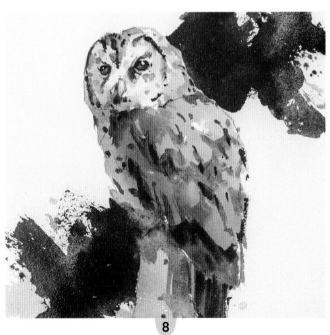

8

Make any final tweaks you feel necessary – I added some shading to the beak by mixing a little quinacridone red into creamy new gamboge. This will help it to stand out a little.

SCARLET MACAW

This project will give you a chance to practise keeping colours clean and vibrant while working wet in wet, and expand your language of brushwork. Finally, we'll bring the painting together with some fine detail around the eye and beak – who's a pretty boy, then?

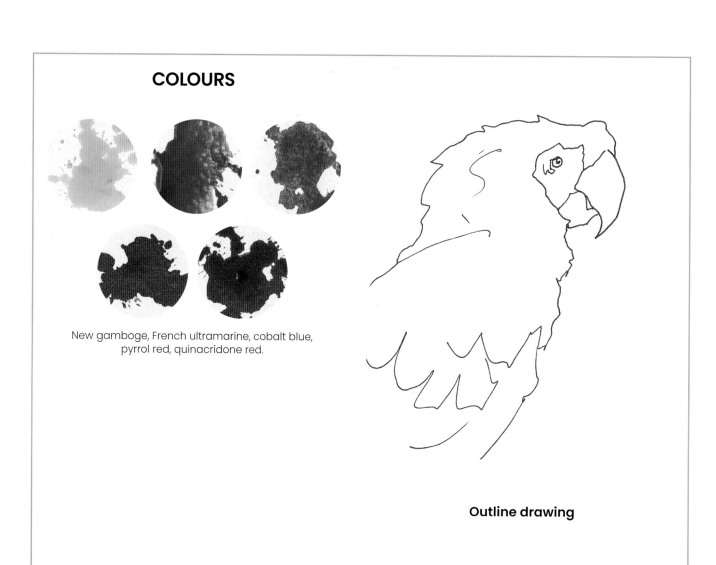

COLOURS

New gamboge, French ultramarine, cobalt blue, pyrrol red, quinacridone red.

Outline drawing

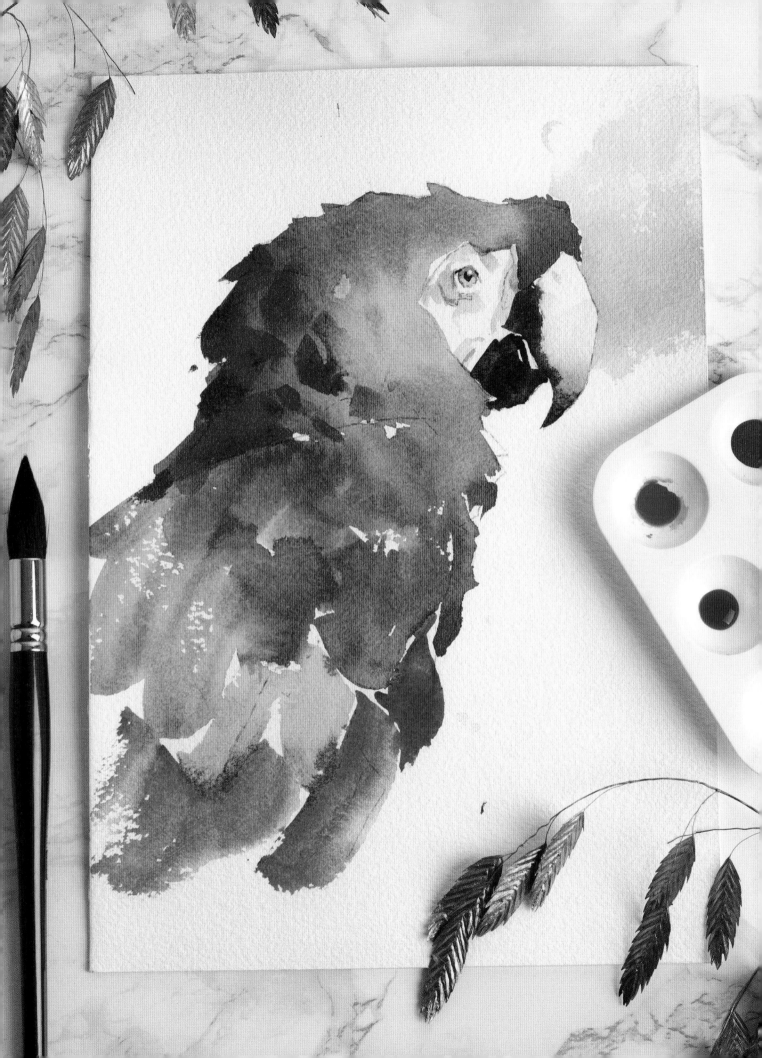

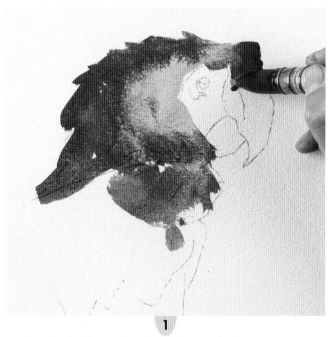

1

Using the size 6 mop brush, apply a wash of new gamboge to map in the lighter areas of the head. Working wet into wet, introduce increasing small amounts of pyrrol red to the yellow mix as you work outwards.

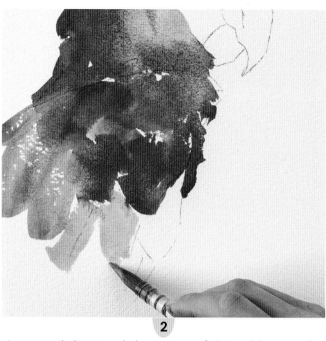

2

As you work downwards, leave gaps of clean white paper for highlights and to suggest the texture of the feathers. Reduce the proportion of red further down the back and increase your use of creamy new gamboge.

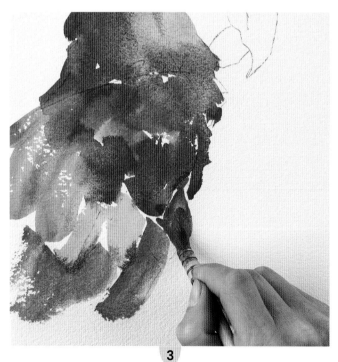

3

Swap to the size 1 brush, and use pure new gamboge wet in wet to add some yellow feathers at the bottom. Once the sheen has gone from these feathers, add some cobalt blue strokes below them, allowing some incidental green to appear where the colours kiss.

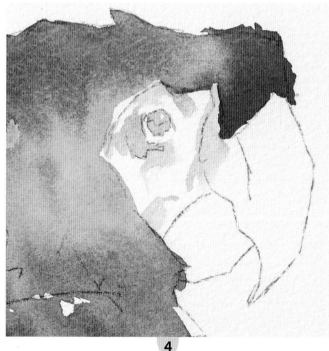

4

The colour of the eye is a light green, so add a tiny touch of cobalt blue to watery new gamboge, and fill in the eye, leaving a highlight of clean paper at the top right. For the shadow on the face, use the tip of the size 3/0 brush to add fine marks with milky French ultramarine.

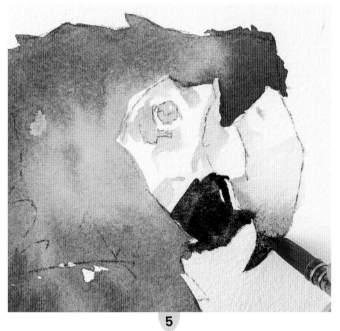

5

Use a creamy mix of quinacridone red with French ultramarine and add a little new gamboge to make a dark mix. Use this to paint in the lower beak. Dilute the mix and paint the tip of the upper beak. Rinse the brush and soften the colour upwards towards the base of the beak, letting it fade to nothing.

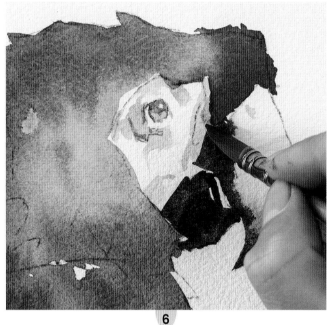

6

Add a dilute mix around the eye to develop the detail as the sheen fades from the upper beak. Before the beak dries completely, add the creamy dark mix to its base, and allow it to gently bleed into the upper beak.

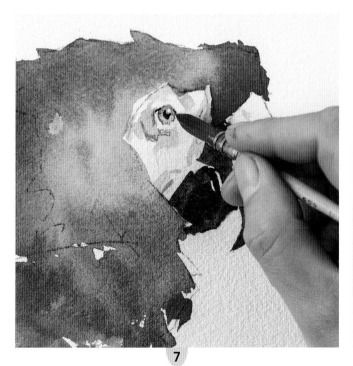

7

Mix French ultramarine with new gamboge and a hint of quinacridone red, and strengthen the eye at the top, leaving highlights at the top and bottom. Allow to dry, then strengthen the depth with the dark mix.

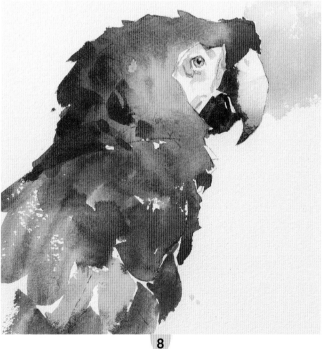

8

Use creamy quinacridone red to add some depth to the feathers at the back of the neck – but keep this simple to avoid losing the loose feel. Add a hint of background, to trap the light and help define the beak, using a watery earthy green mix of new gamboge and French ultramarine.

ROBIN

When painting a bird with clearly visible areas of colour like a robin, we need to be able to work wet in wet in small, controlled areas, while not losing sight of the overall picture – this project will help you bring it all together.

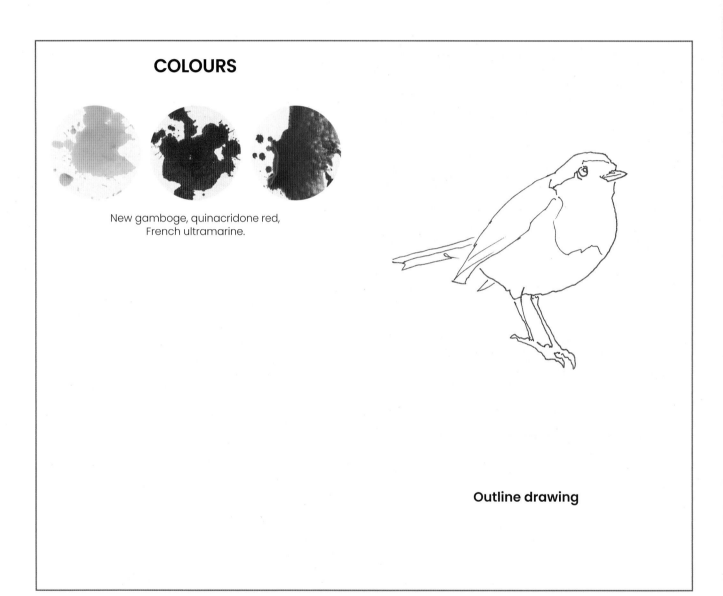

COLOURS

New gamboge, quinacridone red, French ultramarine.

Outline drawing

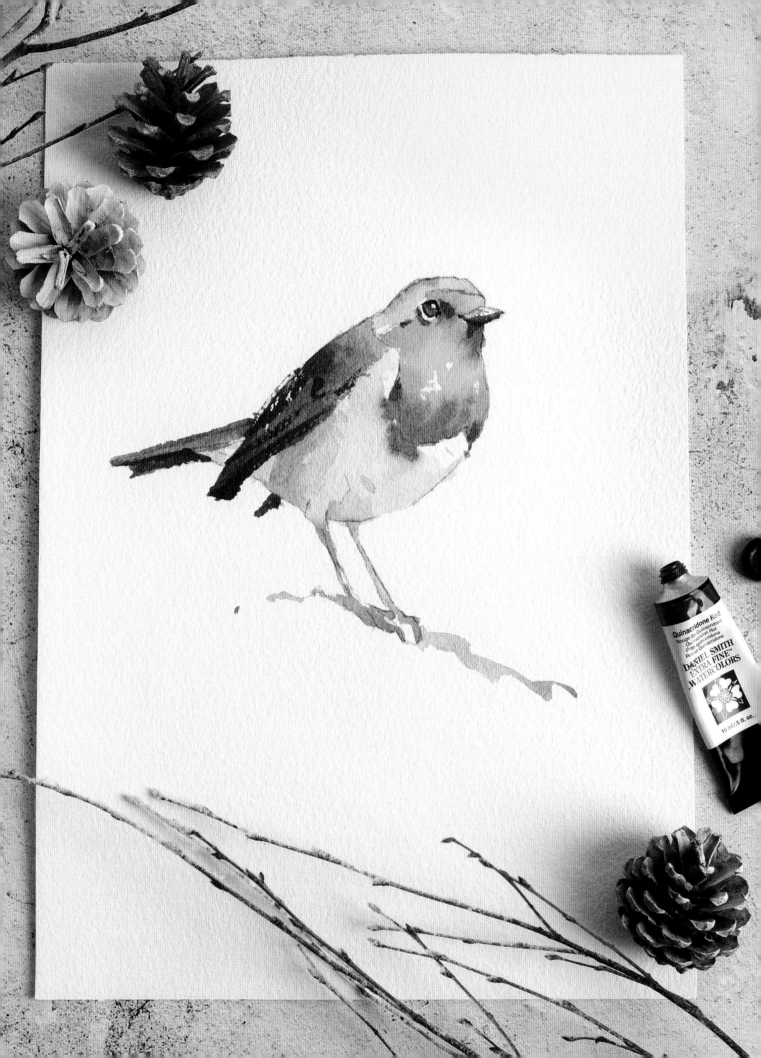

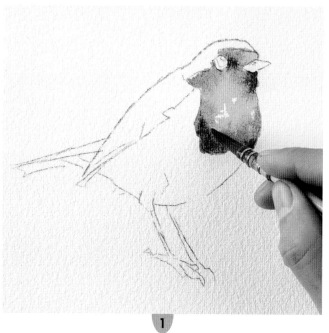

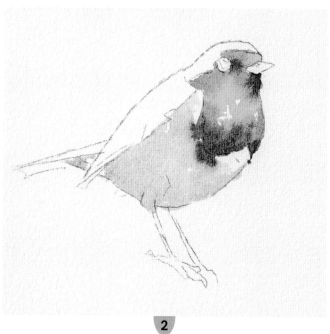

Use a watery mix of new gamboge and a touch of quinacridone red to make a soft yellowy-orange. Use a size 1 brush to paint the breast with this. Add a little more quinacridone red and a tiny touch of French ultramarine to deepen the tone. Use this to add some shaping and depth to the red breast.

Make a soft blue-grey mix from French ultramarine with touches of quinacridone red and new gamboge. Use this to paint the white portion of the body, leaving highlights and letting it just kiss the damp edge of the red breast.

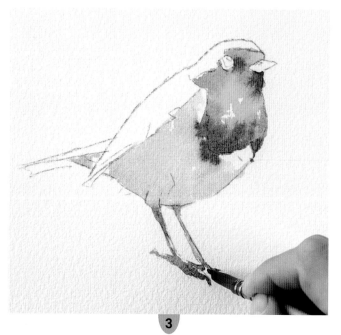

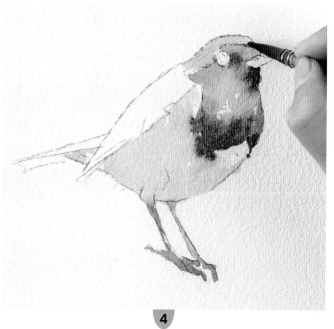

Strengthen the blue-grey mix with a little more quinacridone red and use the size 3/0 brush to paint the legs.

Use the original blue-grey mix (see step 2) to paint the robin's head and upper back, working from the top of the head downwards.

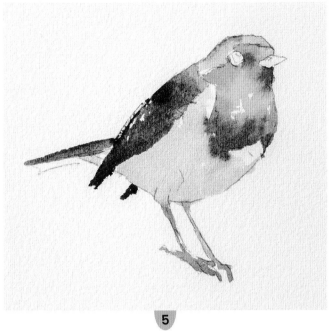

5

Swap to the size 1 brush. Introduce more quinacridone red and new gamboge to the same mix for the wings, then strengthen it still further with the same colours for the tail.

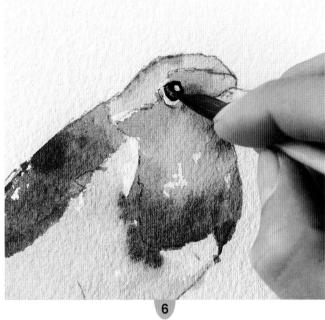

6

Use a creamy dark mix, made from all three paints, to add the eye. Use the tip of the size 3/0 brush to apply the paint, leaving a clean white highlight. Rinse and remove the excess water from the brush, then draw the tip of the damp brush in a curve across the bottom of the eye to lift out a highlight.

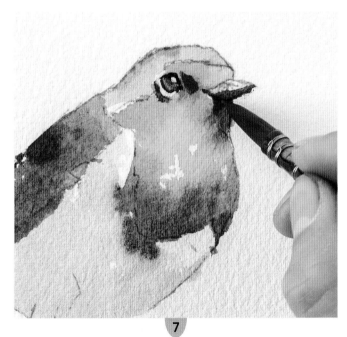

7

Use the same mix and brush to paint the lower beak. Rinse the brush and use it to draw the colour upwards into the upper beak. Use a creamy mix of new gamboge and quinacridone red to strengthen a few details on the face to help 'sit' the beak and eye in place.

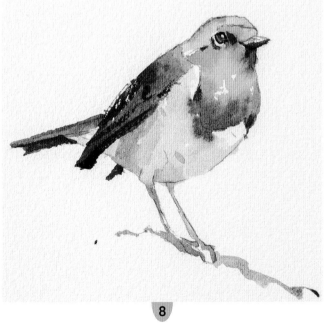

8

Add some finishing details to the body and wing with the size 3/0 brush and the mixes on your palette. Use a dilute mix of French ultramarine to add shadows to the body, and to add a wandering line as a simple cast shadow beneath the robin.

CARMINE BEE-EATER

Many birds have clear and distinct areas of very different plumage, so learning how to keep those separate is key. Of course, we don't want our birds to look stiff and lifeless, so this project will show you how to balance control with loosening up by adding a fun and dynamic splashy background.

COLOURS

Cobalt teal blue, quinacridone red, French ultramarine, aureolin.

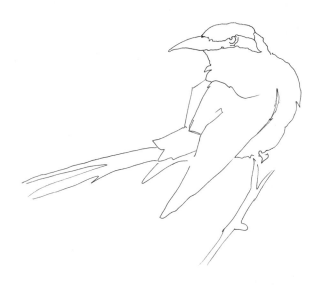

Outline drawing

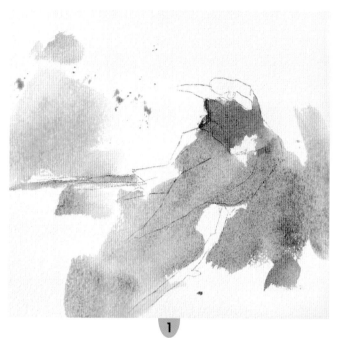

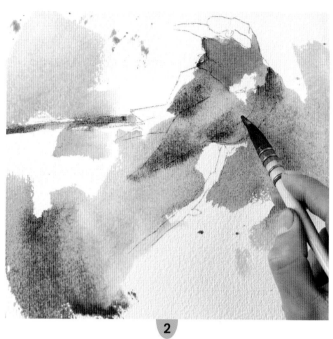

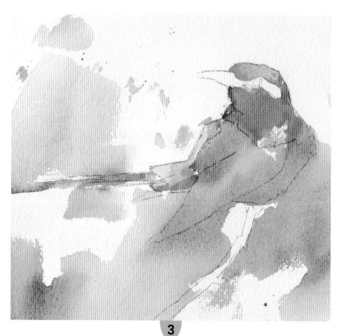

1

Block in the bird's neck and body using the size 1 brush and a mix of watery quinacridone red with a touch of aureolin. Extend the colour into the background, avoiding the areas on the head and tail that will be turquoise.

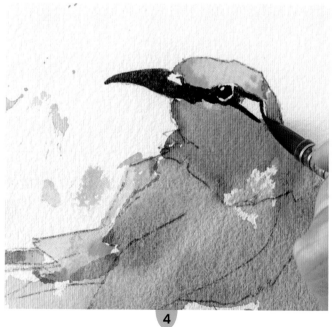

2

Use dilute quinacridone red towards the lower right, and add some splashes and spatters. Soften any unwanted hard edges with a clean damp brush while the paint is wet. Add a few strengthening marks of the orange-tinged mix to the bird itself.

3

Once dry, use milky cobalt teal blue to add the turquoise areas on the head and tail – and a few marks in the background. Drop in creamier cobalt teal blue to add shaping.

4

Swap to the size 3/0 brush and use a creamy dark mix of French ultramarine, quinacridone red and aureolin to paint the beak. Continue the dark area into the eye band and eye itself, leaving hints of white at the top of the beak and beneath the eye.

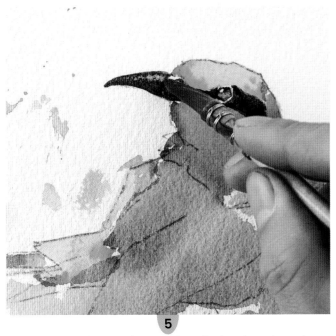

5

While the paint remains wet, rinse the brush and use the damp tip to lift out some soft highlights on the eye and beak.

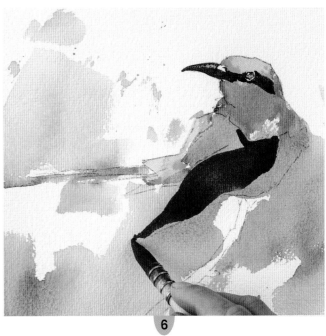

6

Make a rich, creamy chestnut mix of quinacridone red with a touch of aureolin and a tiny touch of French ultramarine. Use this to paint in the wing with smooth strokes of the size 1 brush.

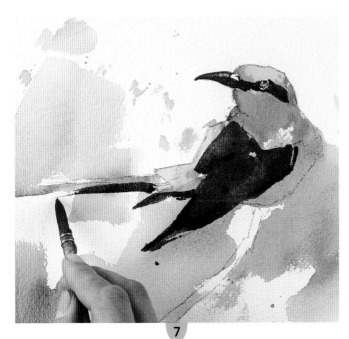

7

While the chestnut mix remains wet, add definition to the wing with a dark mix of French ultramarine, quinacridone red and aureolin. Paint the other wingtip and tail with the same mix.

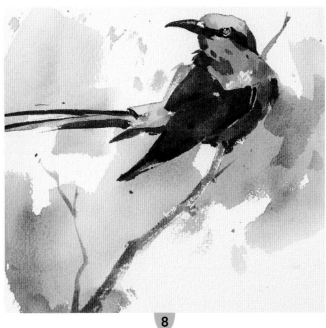

8

Use a mix of quinacridone red and aureolin to add depth and shaping to the bee-eater's body and neck. Add more aureolin to the mix and paint in the branch with light strokes.

KINGFISHER

Continuing the theme of keeping colours separate, bold halcyon blue and sunny orange will become grey and dull if allowed to mix – so concentrate on keeping colours clear and vibrant. We'll also bring more background into this project to show how best to set off plumage as bright as this kingfisher's.

COLOURS

Phthalo blue (green shade), quinacridone red, aureolin.

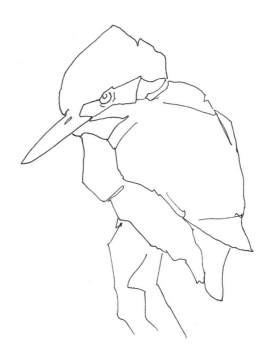

Outline drawing

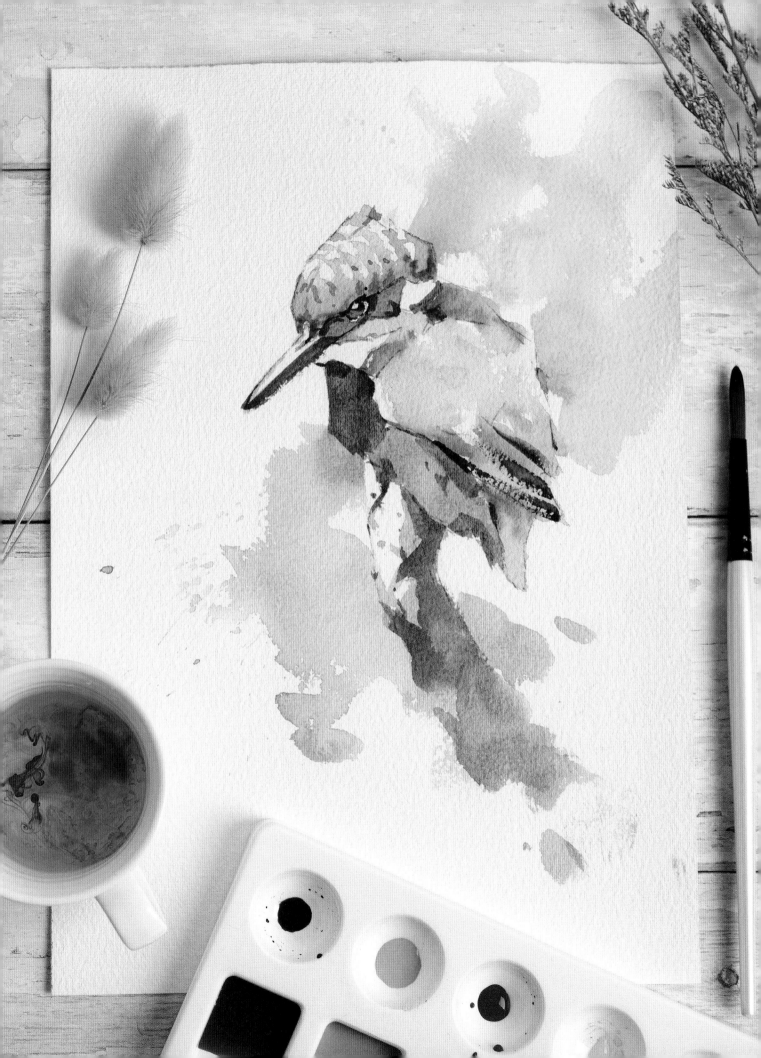

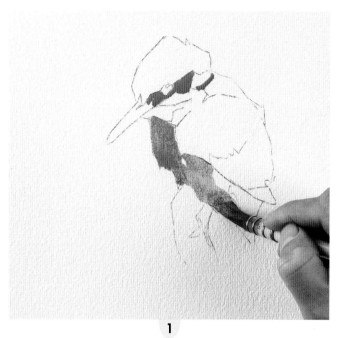

1

Make a milky orange mix of aureolin and a little quinacridone red. Use the the size 1 brush to block in the orange on the face and body with loose strokes.

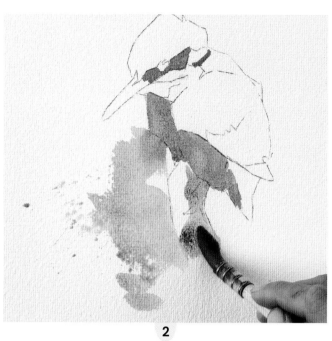

2

Extend the orange into the background on the lower left and add a few spatters for interest, too. Add a little more quinacridone red and some French ultramarine to the mix to make a brown, and use this to paint the branch.

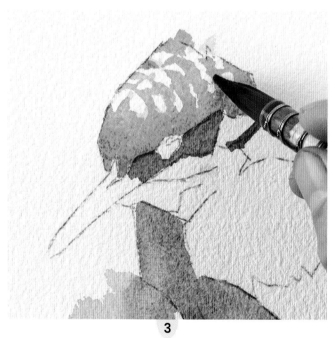

3

Allow to dry completely – it's key that the orange and blue-turquoise don't mix. Prepare some watery phthalo blue and use the tip of the size 1 to carefully paint the head, suggesting the regular rows of tiny feathers by leaving plenty of white space between parallel curved strokes. Think about the curvature of the head to get the shape right.

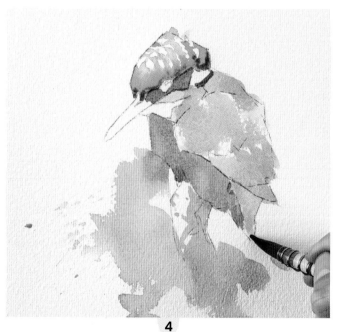

4

While the phthalo blue on the head remains damp, drop in some creamier phthalo blue at the bottom of the area to strengthen the tone. Working down the kingfisher, paint the body and wing in a similar way, starting with dilute phthalo blue.

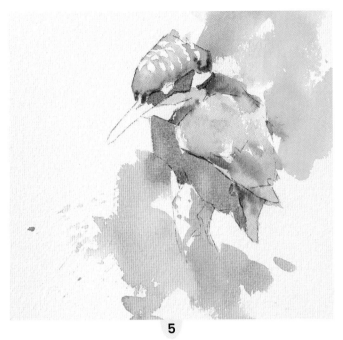

5

Paying attention to the size of the feathers in each area, use strong phthalo blue to define the wing a little. Add a touch of phthalo blue to aureolin to make a vibrant mix and add a loose background with the size 1 brush; working right up to the kingfisher to allow the phthalo blue to bleed out into it a little.

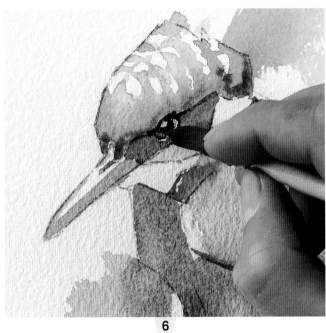

6

Block in the beak with a dilute mix of quinacridone red with a touch of phthalo blue, leaving highlights. Strengthen this mix and add a little aureolin to make a dark mix and paint the eye. Again, leave a highlight, then use the tip of the size 3/0 brush to lift out a curved highlight at the bottom.

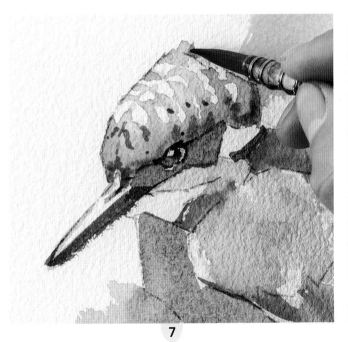

7

Using the same dark mix, paint in the lower beak, then use phthalo blue to add some fine details to the top of the head – don't go overboard; a few fine lines and dots are all you need to suggest the texture.

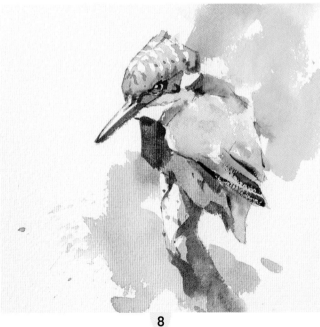

8

Refine the wing in the same way, then use the brown mix from step 2 to shade and detail the orange areas. Add a shadow on the branch with the dark mix to finish.

MANDARIN DUCK

This is a perfect project to practise gradients and blending. With so many separate areas of colour, this is a great exercise in pigment control – and how darker colours and details can tie together a complex picture. When adding the markings, take things slowly, and make sure you're confident about which colours you're using in each area before you start. Throughout, pay attention to how dry the area is next to where you are painting. If in doubt, wait.

COLOURS

Phthalo blue (green shade), quinacridone red, French ultramarine, aureolin.

Outline drawing

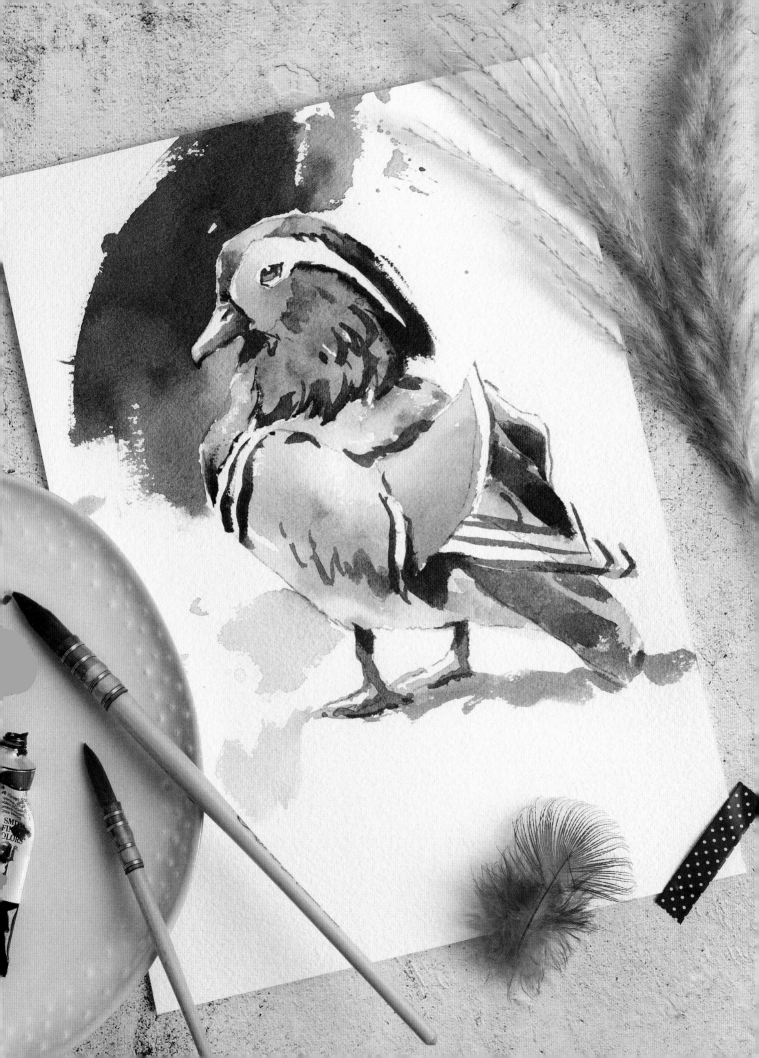

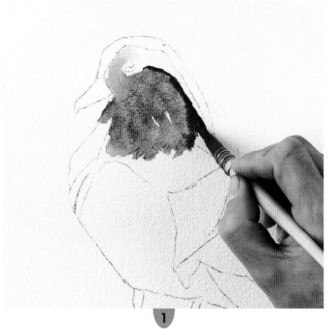

1

Use the size 1 brush to apply aureolin to the head below the eye, as shown. As you work down, gradually introduce quinacridone red to create a gradient from yellow, through orange, to richer orange. Introduce a creamy dark mix of quinacridone red with a tiny touch of French ultramarine to the rear edge of the area while the paint is wet.

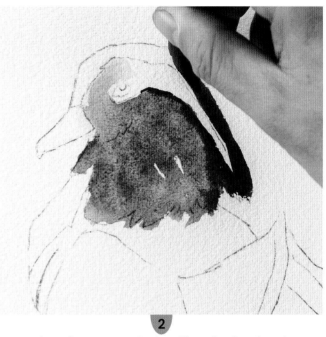

2

Draw the colour up over the head in as few brushstrokes as possible. Concentrate on the white area that you're leaving. Rinse the brush, then draw the orange mix back into it from the top, letting the colours bleed into one another.

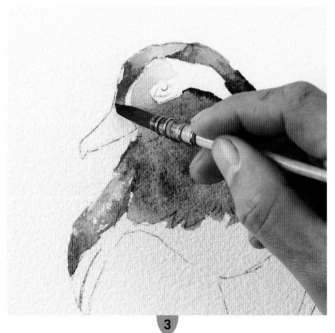

3

Strengthen the bottom of the dark area with the dark mix from step 1. Paint the breast feathers with a purple mix of quinacridone red and a little French ultramarine. Swap to watery phthalo blue for the bright feathers on the top of the duck's head. Increase the strength of the blue nearer the beak.

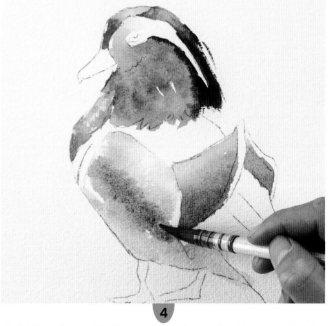

4

Paint the wings with the orange mix, varying the hues slightly in each area by tweaking the proportions of the yellow to red in the mixes. Pay attention to the gradients to suggest the form of the duck, adding more water to blend the colour away where necessary, and adding more paint to strengthen and suggest shadow.

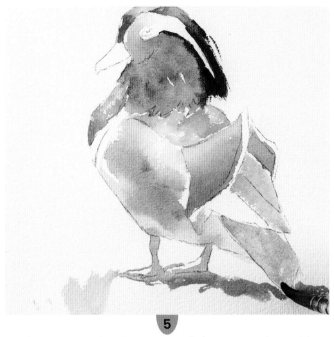

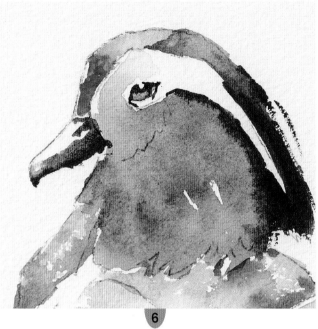

5

Paint the legs using the orange mix from step 1, then add a little French ultramarine and quinacridone red to the orange mix to subdue the colour (see page 19), and use this to paint a cast shadow under the duck. Allow to dry, then use watery phthalo blue to block in the blue areas.

6

Swap to the size 3/0 brush. Once dry, paint the beak using quinacridone red. Use the strong dark mix to paint the eye, leaving a paper highlight and lifting out a crescent at the bottom with the tip of the clean, damp brush.

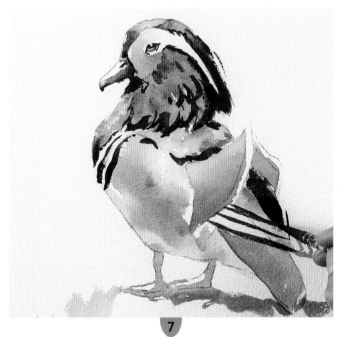

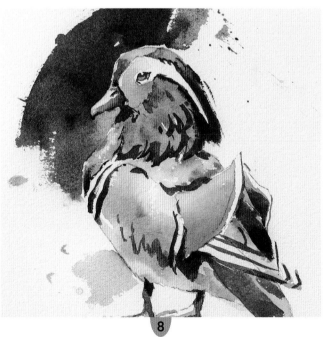

7

Using stronger mixes of the respective colours and mixes used earlier, add the markings in each area in turn. Work down from the top of the head, one area at a time. This way you can break down what can feel intimidating into small, simple steps.

8

Mix aureolin with phthalo blue and a hint of quinacridone red. Use the resulting deep green mix to paint a bold background around the head, to trap the light and set off the bold colours of the duck.

HOOPOE

Big bold splashes of colour suit this fantastic-looking bird, and its striking markings can be picked out with simple brushstrokes.

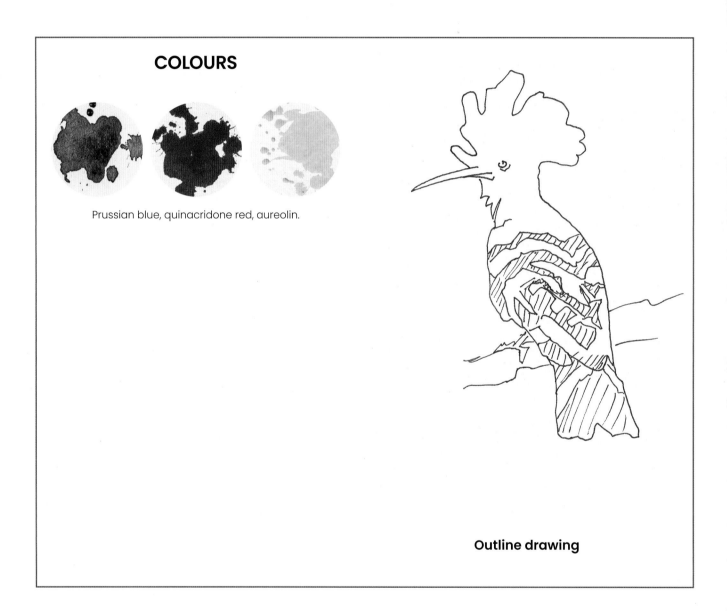

COLOURS

Prussian blue, quinacridone red, aureolin.

Outline drawing

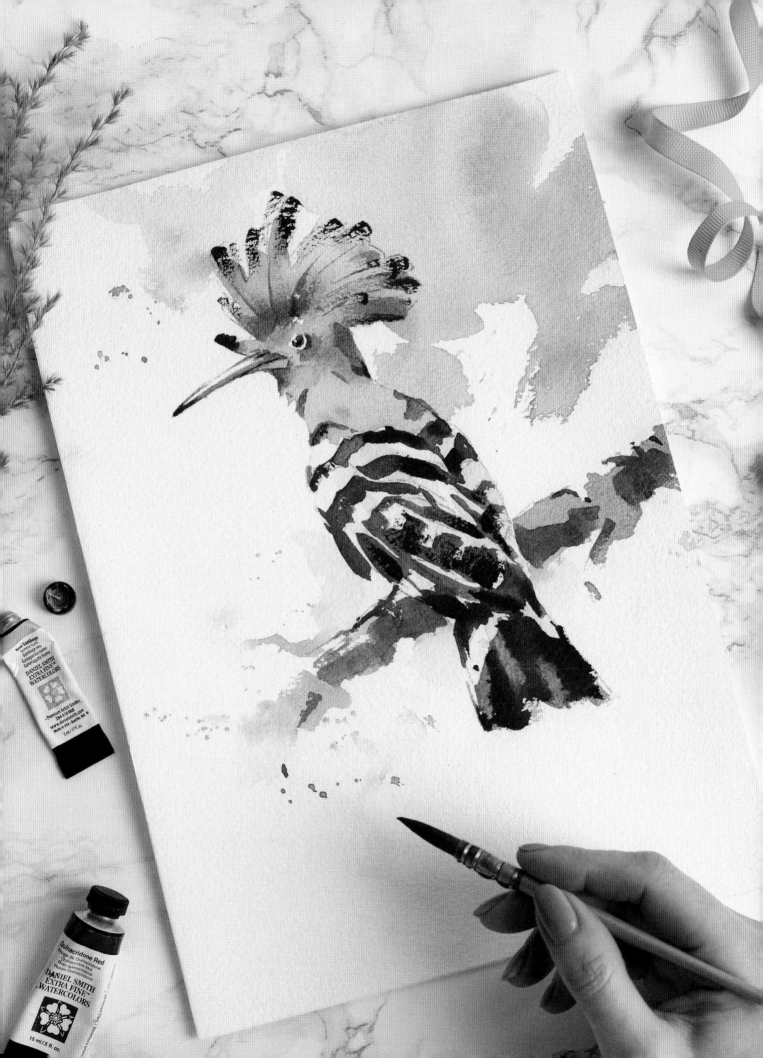

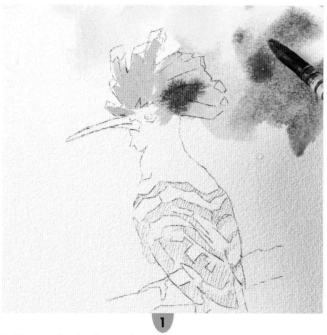

1

Add a touch of quinacridone red to aureolin and use the size 1 brush to apply this orange mix to the crest. Extend the colour into the background, then inject a little more red to the mix to add some variety.

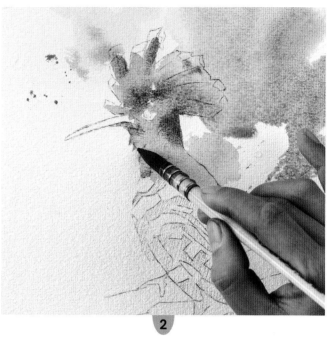

2

Leaving light around the eye, build up the head. Strengthen the mix to a milky consistency and add shaping wet into wet.

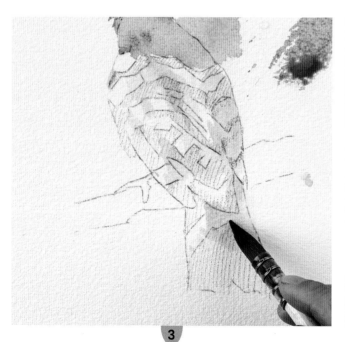

3

Glaze very dilute Prussian blue over the bird's back to establish some subtle shadow. Ignore the markings at this point and just treat the body as a single large shape.

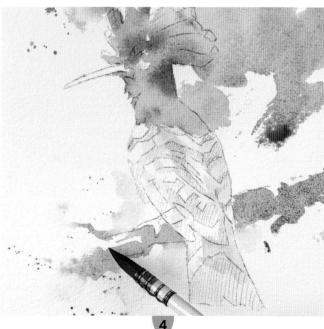

4

Make a muted grey-green mix of aureolin with a little Prussian blue and a touch of quinacridone red and use this to paint the branch. Add a little spattering to the lower left, then leave the whole painting to dry.

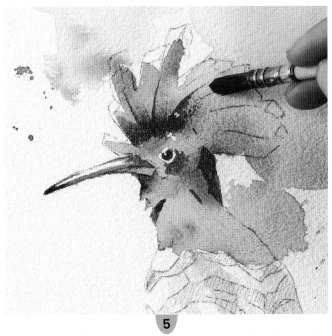

5

Use the size 3/0 brush to paint the lower part of the beak with a soft grey mix of Prussian blue with a little quinacridone red and aureolin. Add a very fine line at the top of the beak, leaving a white highlight. Paint the eye with the same mix, then build up the shape on the head with a strong version of the orange mix from step 1.

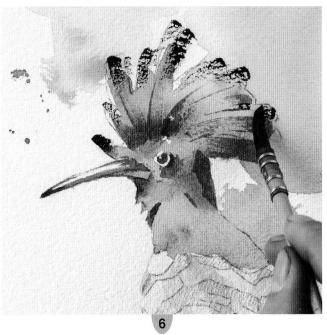

6

Use the same strong orange mix for some light strokes on the crest, then make a thick, dark mix of quinacridone red and Prussian blue. Use this with an almost dry brush and a light touch to give hard marks, and begin to pick out the markings on the crest.

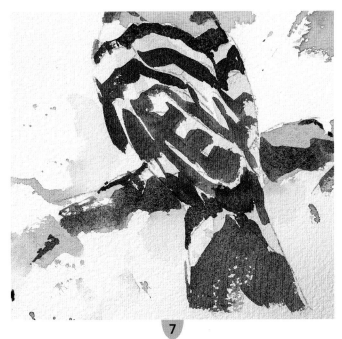

7

In order not to go too dark at the start, use the same dark mix at a milky consistency to add the markings on the hoopoe's back. Paint the visible leg with a grey mix of all three colours, then add more aureolin to get a dark green for shadow under the branch.

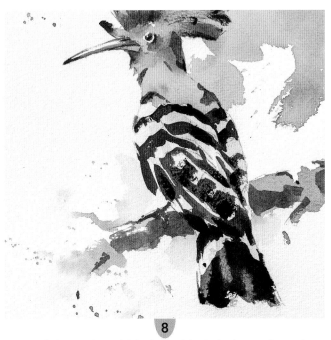

8

To finish, make a thick, deep, rich dark of aureolin and Prussian blue and use this almost dry to add strength to the markings selectively.

BLUE JAY

Small markings can quickly make a subject too complex and messy, so we must simplify them. We'll also explore the properties of different blues in this project by using both a cool and a warm blue – respectively phthalo blue (green shade) and cobalt blue.

COLOURS

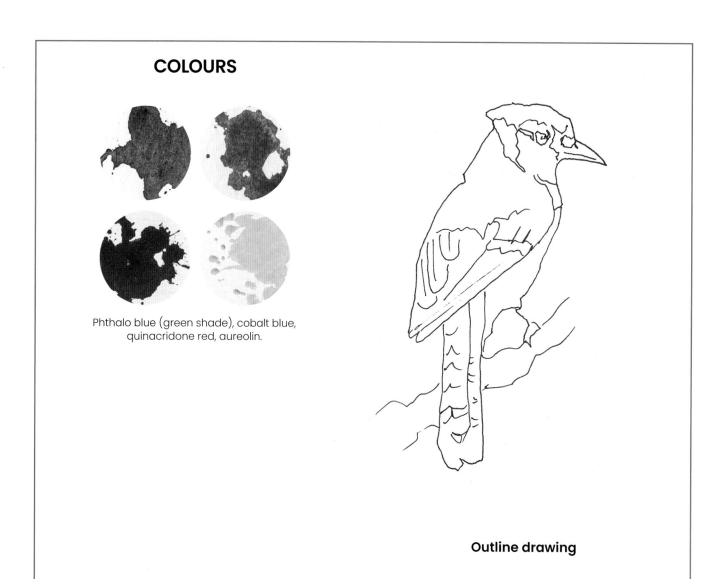

Phthalo blue (green shade), cobalt blue, quinacridone red, aureolin.

Outline drawing

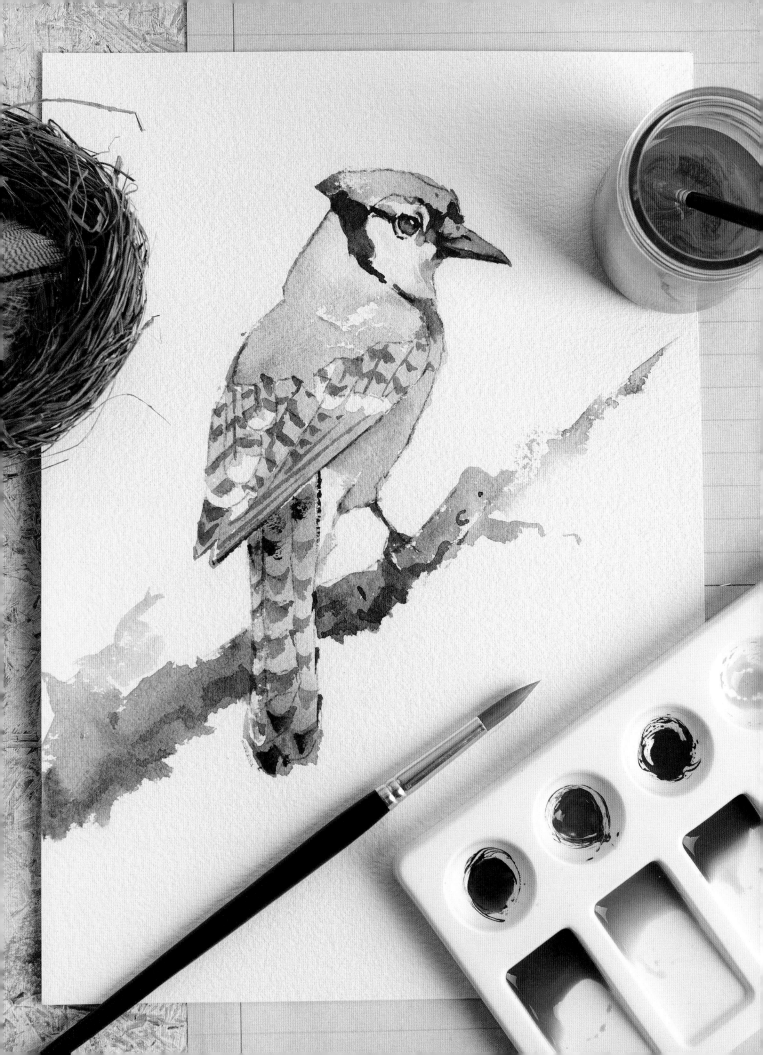

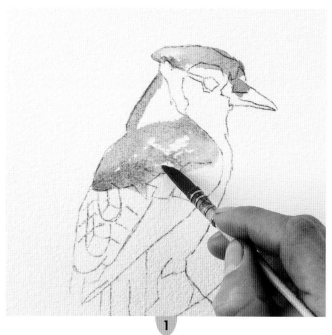

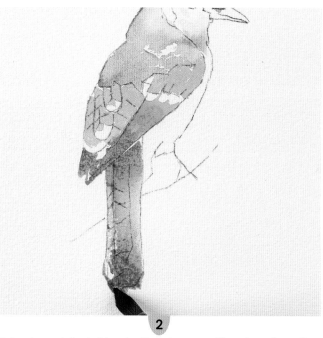

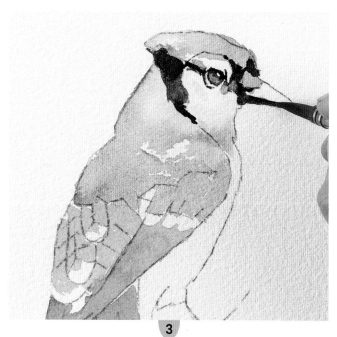

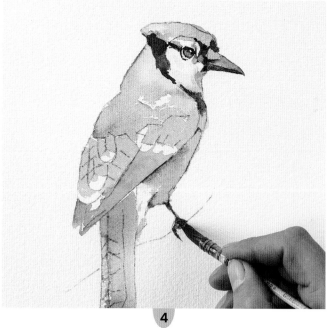

1

Prepare some milky cobalt blue and block in the blue jay's upper body, using the size 3/0 brush to apply the paint. Vary the consistency across the cap and back.

2

Introduce phthalo blue for the wings, working down from the top. Be careful to leave the patches for the markings as clean white paper. Swap to a size 1 brush for the larger feathers of the wing and the tail.

3

Make a dark mix from phthalo blue with touches of quinacridone red and aureolin. Use the size 3/0 brush to paint the eye, leaving a small paper highlight and lifting out a soft highlight with the tip of the brush. Use the same brush and mix to paint the markings on the head and the lower beak.

4

For the upper part of the beak, dilute the dark mix a little. Dilute the dark mix and add a spot more quinacridone red to the mix to create a muted purple. Glaze the bird's breast with this new mix. Use the same mix for the visible foot.

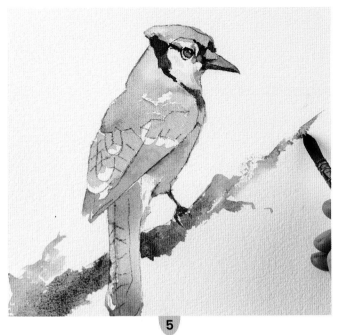

5

Add the branch with a brown mix of aureolin, quinacridone red and a little phthalo blue.

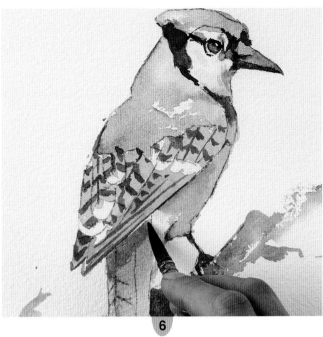

6

For the markings on the wings, use a milky version of the dark mix used in step 3. Concentrate on working gradually. The key to these clean, crisp markings is to keep your brushstrokes simple. Don't use the mix too strong, or the marks will appear too stark.

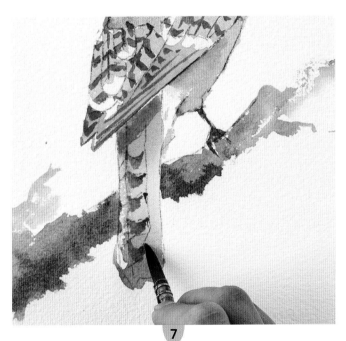

7

Reinforce the blue on the tail, creating the markings with near-neat phthalo blue.

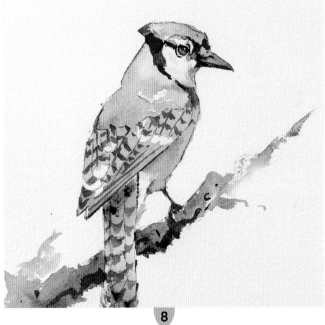

8

To finish, use cobalt blue at a similar thick consistency to add a few touches here and there over the blue jay's head and back. Strengthen the branch with a stronger brown mix from step 5. Finish with a few extra flicks of the strong dark mix from step 3.

BARN OWL

This barn owl is an exercise in very soft muted colours and gentle tones. We'll use heavy, opaque lavender paint to add shading for the white parts – as you'll see, the white of the paper is nothing to be afraid of in watercolour!

COLOURS

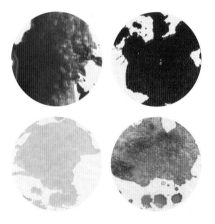

French ultramarine, quinacridone red, aureolin, lavender.

Outline drawing

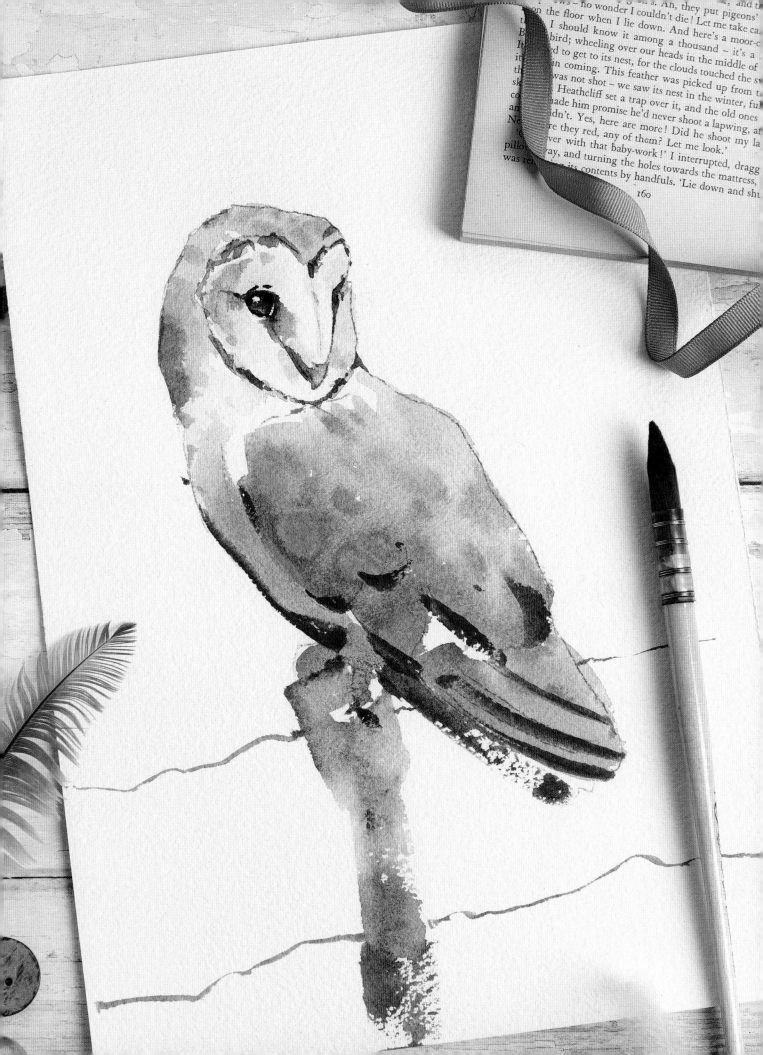

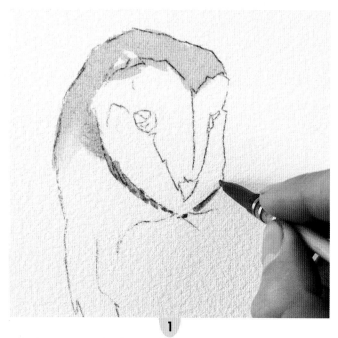

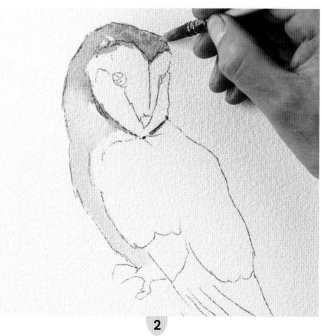

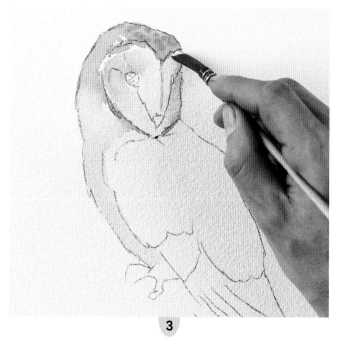

1

Make a warm mix of aureolin with a little quinacridone red and a touch of French ultramarine. Use the size 3/0 brush to paint around the owl's face, blending it away with clean water into the neck.

2

Use watered-down lavender to bring a lovely soft grey down the left-hand side of the owl. With a creamier consistency of lavender, dot in some markings to the top of the head using the tip of the brush.

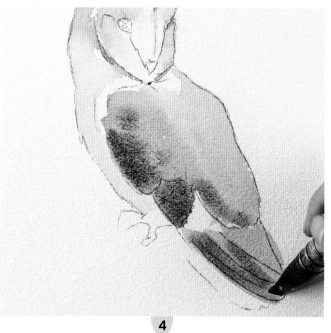

3

Shape the shadows on the face with watery lavender. Soften them away with a clean damp brush, and strengthen areas with the stronger consistency added wet in wet.

4

Add more French ultramarine to the warm mix to mute it a little, and use the size 6 brush to paint the wing and tail. Make your brushstrokes bold to create a little variety and texture. Strengthen the mix to a milky consistency and add colour intensity with more yellow and red to build the depth of tone towards the bottom.

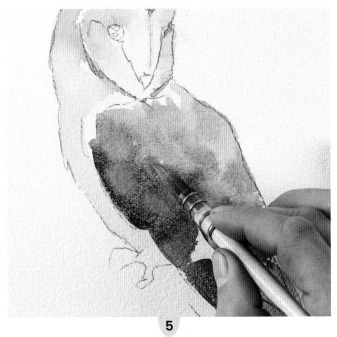

5

While still wet, drop in touches of lavender, at a milky-creamy consistency, to the wet paint of the wing and tail. This paint is quite 'heavy', so it won't bleed as much as you might expect – this makes it perfect for this variegated finish. Allow to dry completely before continuing.

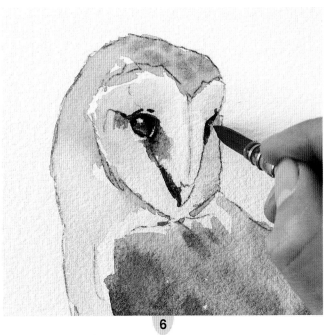

6

Swap to a size 3/0 brush. Use a creamy mix of quinacridone red, aureolin and a touch of French ultramarine to add the facial markings, blending and softening the colour away with a clean damp brush. Add more French ultramarine to the mix for the eye. Avoid the white highlight, and use the tip of a damp brush to lift out a crescent highlight at the bottom.

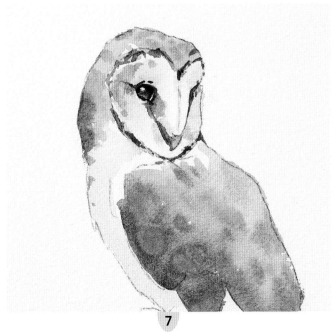

7

Strengthen the markings in the shadows on the face with stronger lavender for the cool areas, and a mix of aureolin and quinacridone red with a touch of French ultramarine for the warm areas. Dilute the warm mix for the shadows on the back of the head.

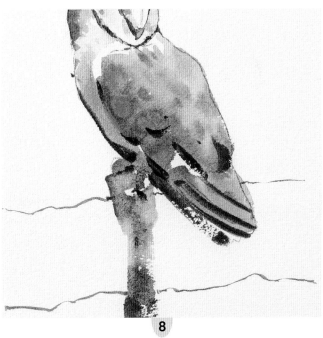

8

Use the darker mix from step 6 to develop the shadows on the owl's breast and add a few flicks on the wings and tail. Use a mix of French ultramarine and quinacridone red for the feet, then dilute and add more red for the gnarled fencepost and wire.

TURTLE DOVE

Here we'll combine muted colours with strong markings. The key to success is striking the right balance between muted and strong colours, and between more complex and simpler areas.

COLOURS

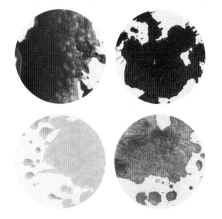

French ultramarine, quinacridone red, aureolin, lavender.

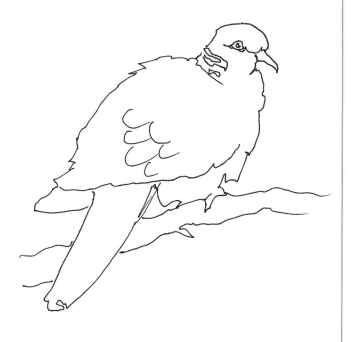

Outline drawing

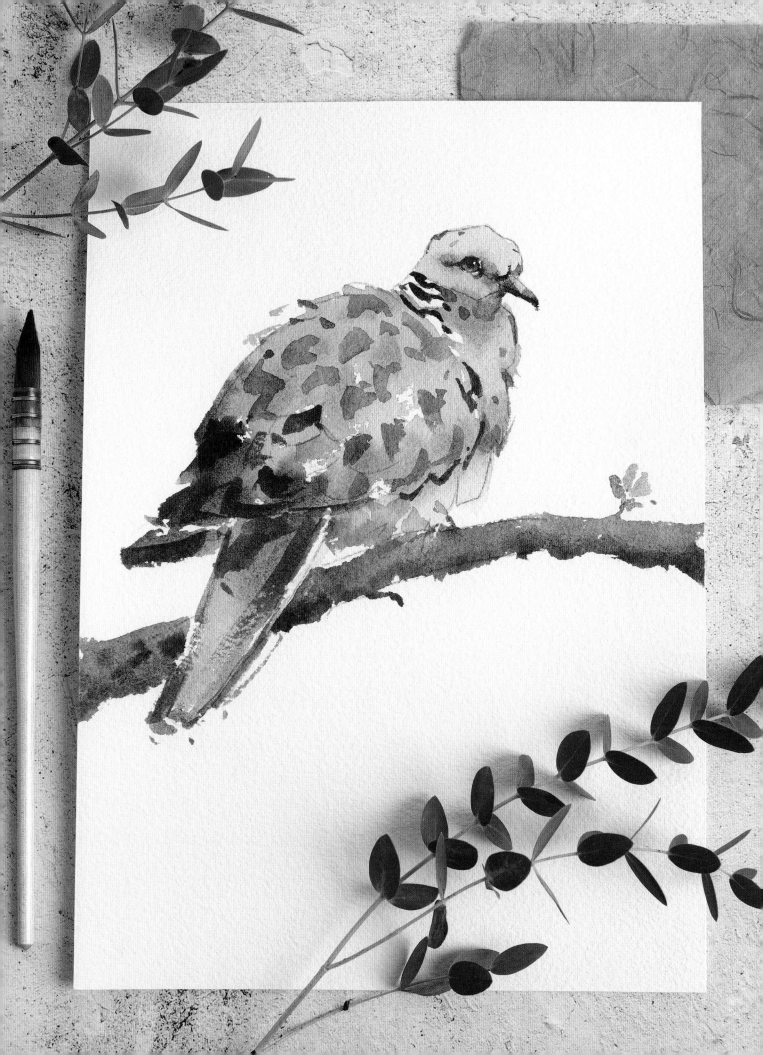

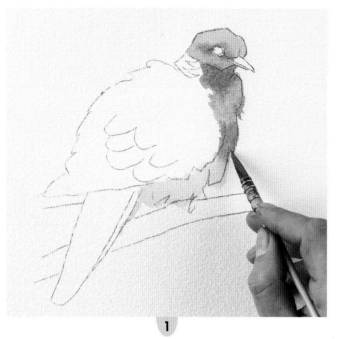

1

Combine lavender with a touch of quinacridone red. Use this at a milky consistency to block in the head and breast, applying the paint with the size 3/0 brush. While wet, add a slightly creamier mix to add depth to the colour on the neck and front.

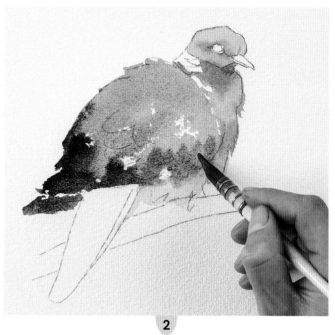

2

Swap to the size 6 brush and use a warm mix of aureolin with a little quinacridone red to paint the wings and back. If it bleeds slightly into the grey of the body, this is a nice bonus. Add French ultramarine to the mix and use this new mix to deepen the tone on the wingtips and bottom of the wing, working wet in wet.

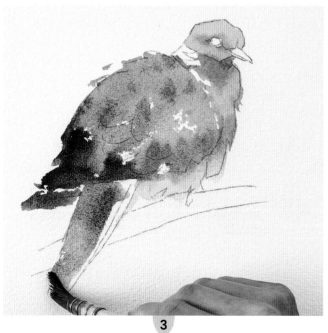

3

Add still more French ultramarine to the same mixture and paint the tail feathers. Aim to do this in just one or two decisive brushstrokes of the size 1 brush.

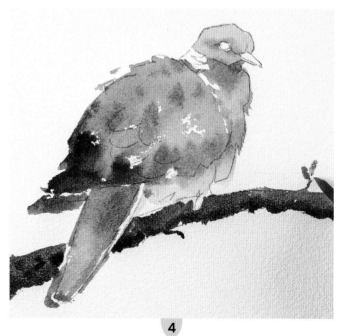

4

Add more quinacridone red and aureolin to the mix to make a warm brown and paint the branch, leaving small gaps of white paper on either side of the tail feathers. Strengthen the mix and add marks as shadow on the bottom of the branch. Add the leaves with a mix of aureolin and French ultramarine.

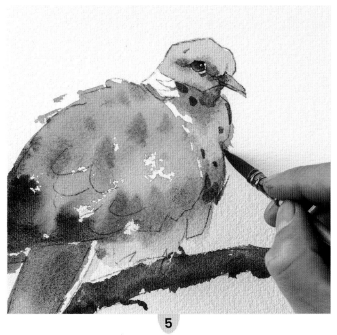

5

Switch to the size 3/0 brush. For the eye, add a base coat of quinacridone red mixed with aureolin. While that dries, paint the beak with lavender mixed with hints of all the other colours. Use this soft grey mix to add some shadow details on the head and breast.

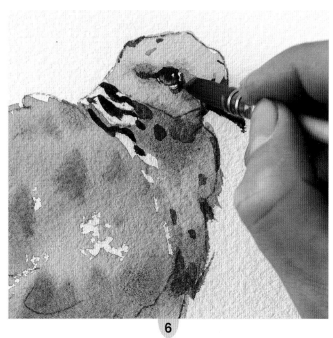

6

Add the pupil of the eye and the dark feathers on the neck with a dark mix of French ultramarine, quinacridone red and a little aureolin.

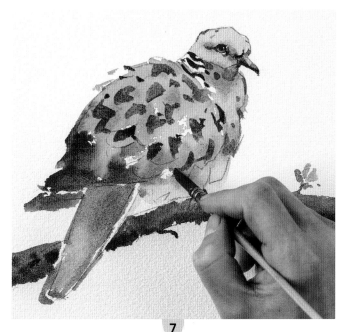

7

Use the same mix to detail the back feathers. Aim to create the impression of the feather pattern, rather than try to duplicate every feather. Place simple marks while thinking about how they fit on the three-dimensional forms of the bird.

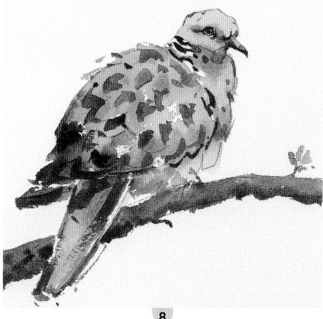

8

To finish, sharpen up areas with the existing mixes on your palette, then add some shadow to the tail with a mix of lavender, French ultramarine and a little quinacridone red and aureolin.

BALD EAGLE

This is a great opportunity for a bold, wet-into-wet approach across almost the whole bird – but rest assured that you can break it down and work in smaller sections if you prefer.

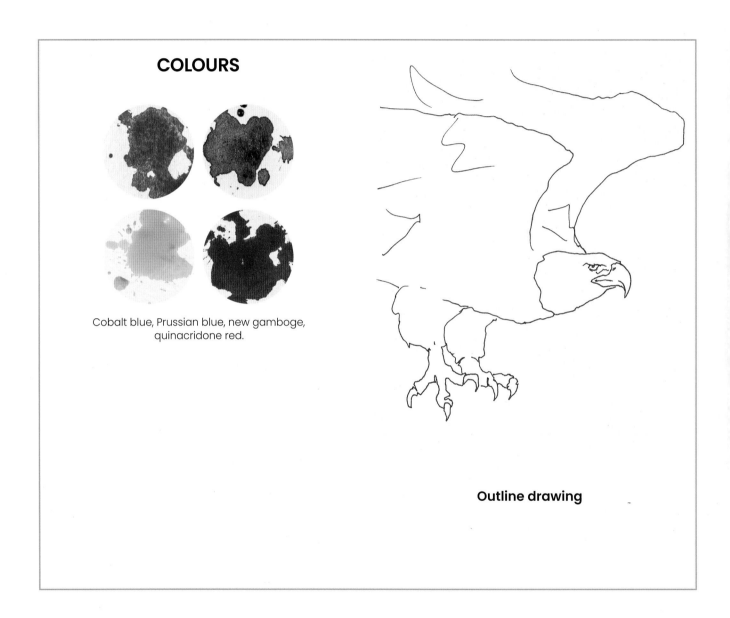

COLOURS

Cobalt blue, Prussian blue, new gamboge, quinacridone red.

Outline drawing

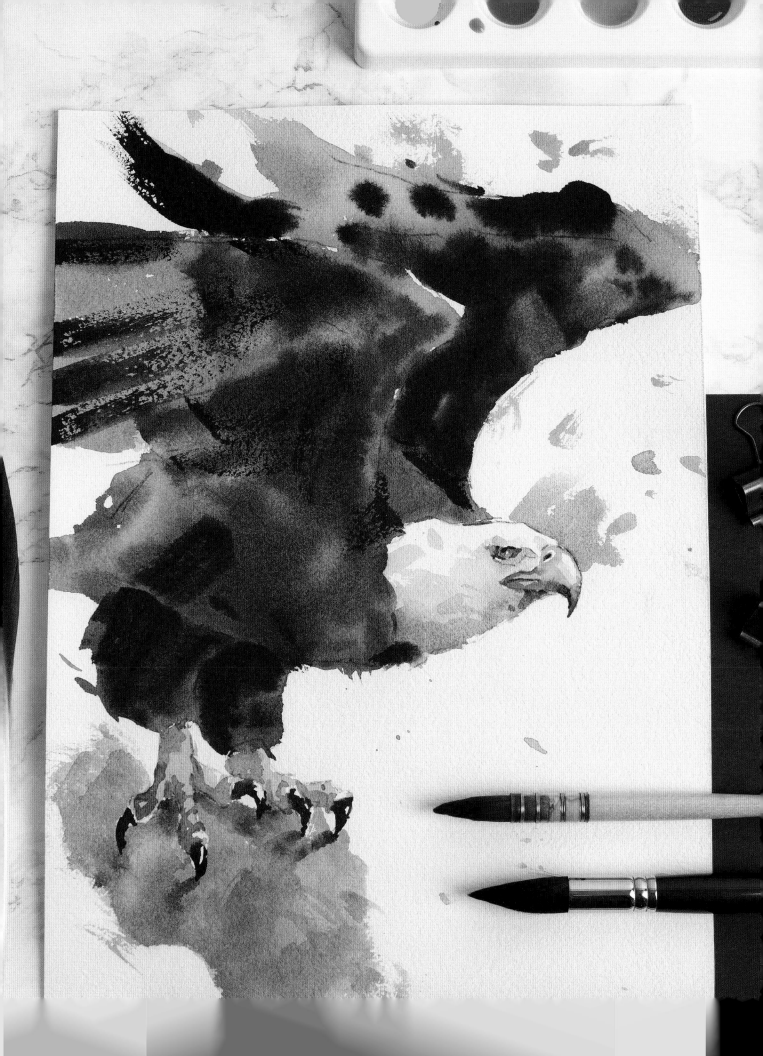

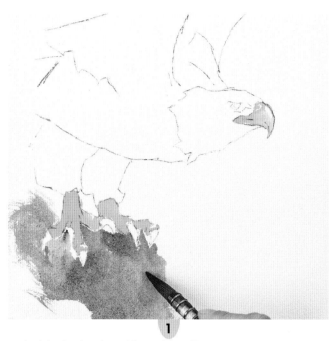

1

Block in the beak and feet with milky new gamboge, using the size 1 brush. Leave a small white space around the nostril, and a line down the beak, as highlights. Mix cobalt blue, new gamboge and quinacridone red to paint the eagle's rocky perch.

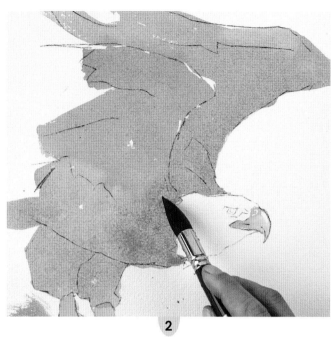

2

Prepare the following mixes: a milky orange-brown mix of quinacridone red with a little new gamboge; and a millky chestnut mix of quinacridone red and cobalt blue with a little new gamboge. Starting from the top of the picture, use the size 12 mop brush to paint in the wings with the orange-brown mix.

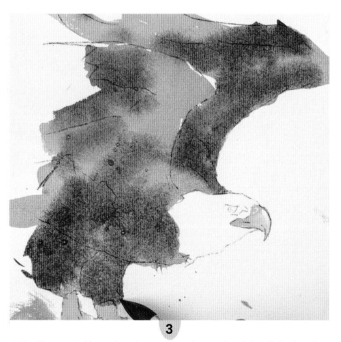

3

Working quickly, paint down over the underside of the body and the legs. While the paint is damp, bring in the chestnut mix wet in wet to create shadows and add depth.

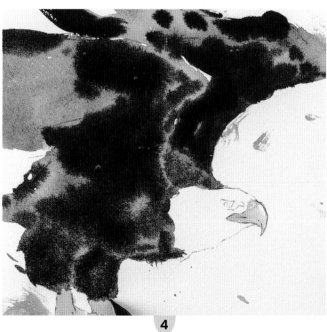

4

Make a deep, dark chestnut mix from Prussian blue, quinacridone red and a touch of new gamboge. Use this to add the really strong darks on the top of the wings. Be generous with these marks, but make sure that the colour doesn't bleed so much that it obscures the shape of the eagle – you should still be able to see the warm highlights on the front of the wings, for example.

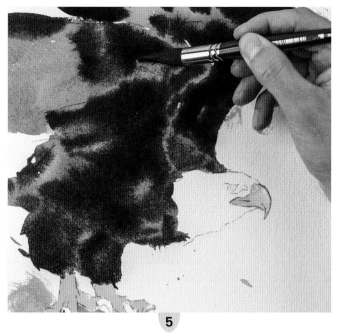

5

While the paint is wet, rinse the brush and dry it, then use it to lift out shapes to suggest the soft feathers. The mop brush is perfect for this, as it will lift a lot of paint, and the pointed tip makes creating a feathery shape easy.

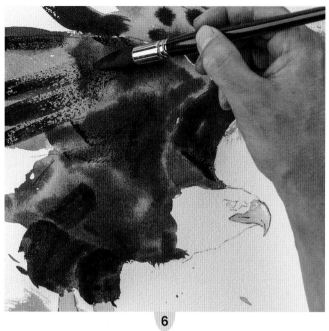

6

When the paint is nearly, but not quite, dry, use a very strong dark mix of Prussian blue, quinacridone red and new gamboge to add some detail to the wings with the dry brush technique.

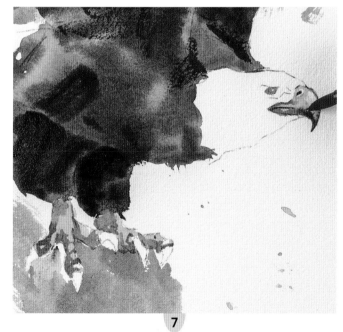

7

Swap down to the size 3/0 brush. Add small touches of quinacridone red and cobalt blue to new gamboge, and use this mix to add shadow and shape to the beak and talons.

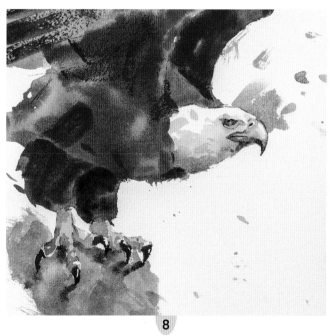

8

Use milky cobalt blue to map out the shadows on the head and neck. Use a very strong dark mix of Prussian blue, quinacridone red and new gamboge to paint the talons and deep detail on the eye, leaving highlights of white paper. Finally, add a little cast shadow on the rock and a splash of background with dilute cobalt blue.

BLUE-AND-GOLD MACAW

There are quite sharp distinctions between areas of colour on a macaw, so be careful to keep them clean. You can avoid them bleeding into one another by allowing adjacent areas to dry wherever possible. There's still lots of opportunity to work wet in wet within each area, so be patient: the fun will come!

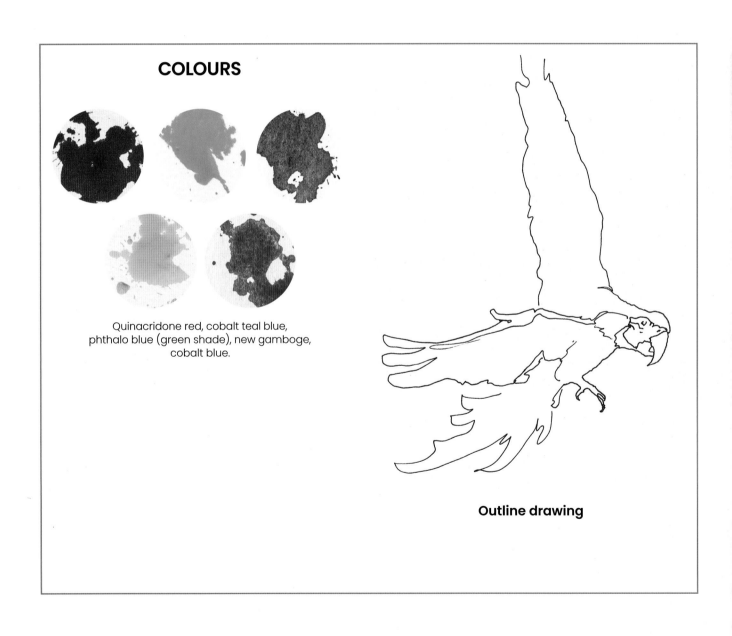

COLOURS

Quinacridone red, cobalt teal blue, phthalo blue (green shade), new gamboge, cobalt blue.

Outline drawing

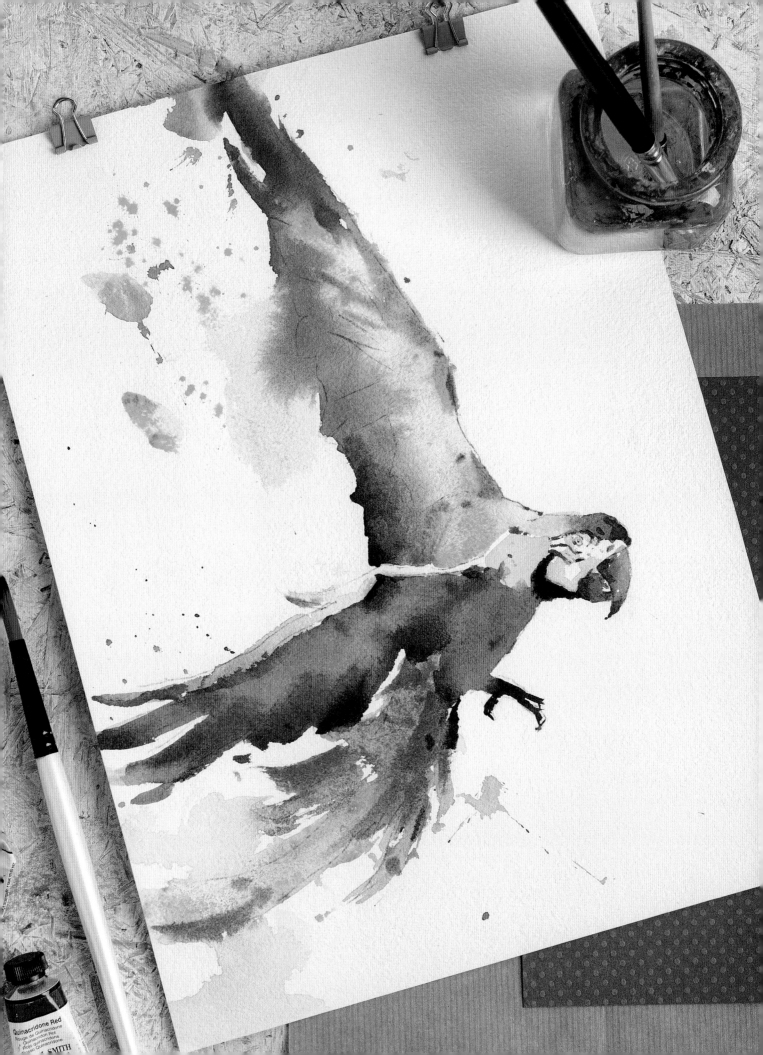

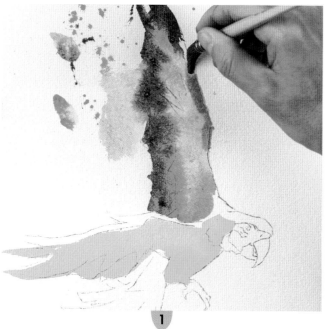

1

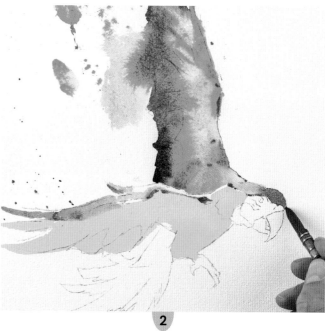

2

Create a watery mix of new gamboge and block in the orange-yellow part of the macaw with the size 1 mop brush. All to dry, then use watery cobalt teal blue to paint the blue wing at the top and the macaw's back. Add some spatters, then add milky phthalo blue wet in wet to the blue feathers for shadow and shape.

Draw the cobalt teal blue along the back, onto the neck and head. Add a little new gamboge to work in the 'cap' on his head wet in wet, letting the paint blend into a subtle green.

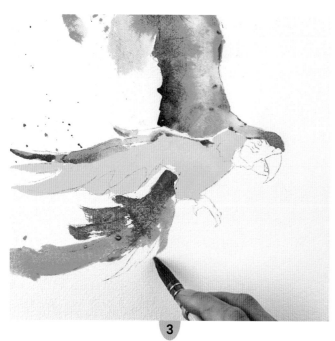

3

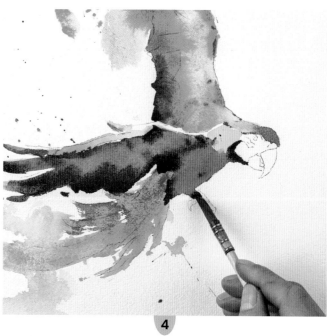

4

Use cobalt blue to paint in the tail, adding touches of cobalt teal blue and phthalo blue wet in wet for continuity and interest. Draw the colour out to create a suggestion of background.

Using a creamy mix of new gamboge and quinacridone red, block in the lower body and underside of the wing in shadow. Soften the edge in a few places to refine it. Add more quinacridone red to the mix for the deeper tones.

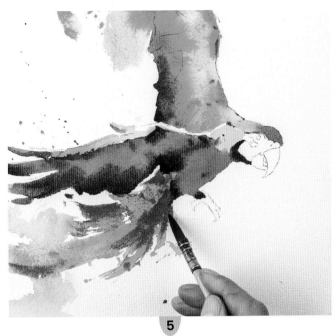

5

Add darker tones in the tail using creamier mixes of all three blues, as in step 3.

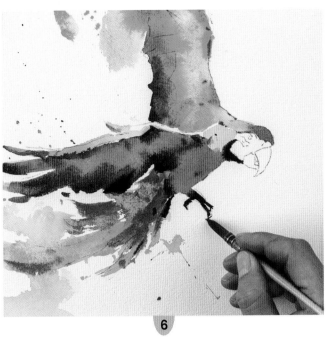

6

Add finishing darks to the orange parts on the underside of the wing, on the throat, and on the feet using a dark, creamy mix of quinacridone red, new gamboge and cobalt blue.

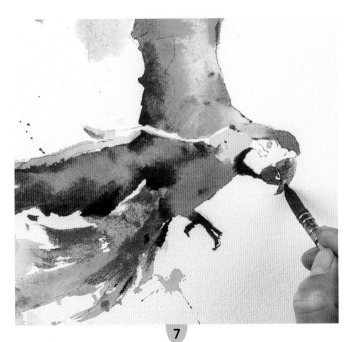

7

Swap to a size 3/0 brush to add a touch of cobalt teal blue to the eye. While that's drying, dilute the dark mix from step 6 to a milky consistency and use it to paint the beak. Soften the colour out to create a sense of form.

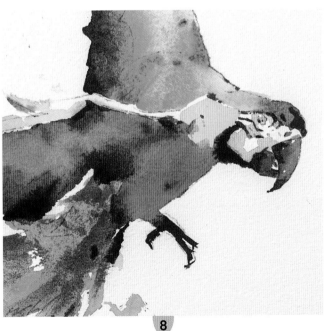

8

Use the same milky mix to paint the markings on the face. Once everything is completely dry, paint the pupil into the eye with the same dark mix, and use a very watery grey mix of cobalt blue and quincridone red with a touch of new gamboge to add a subtle wash to the face.

RESPLENDENT QUETZAL

This project is all about creating movement and energy with bold brushmarks and flowing washes – then adding a little touch of finesse with the eye and beak to make sense of it all.

We're going to be using everything we've learnt so far to bring the whole page to life. Keep it bold and have fun with this wonderful bird!

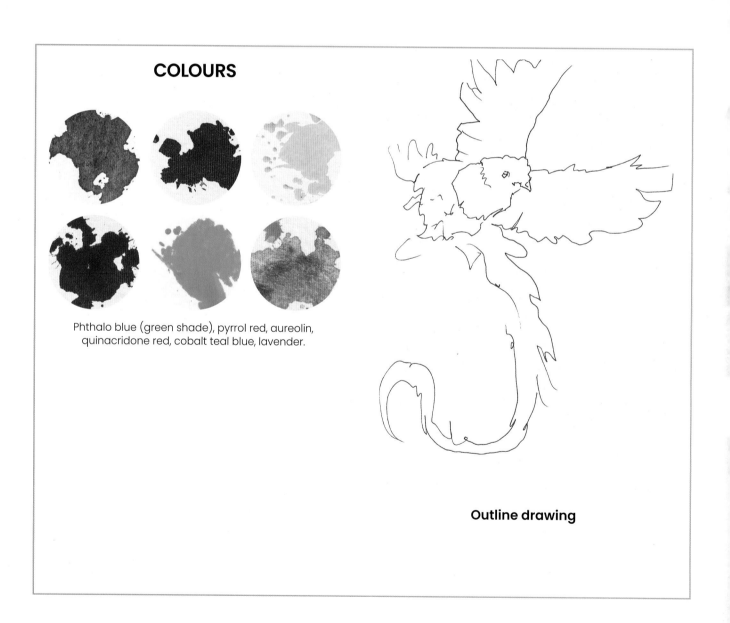

COLOURS

Phthalo blue (green shade), pyrrol red, aureolin, quinacridone red, cobalt teal blue, lavender.

Outline drawing

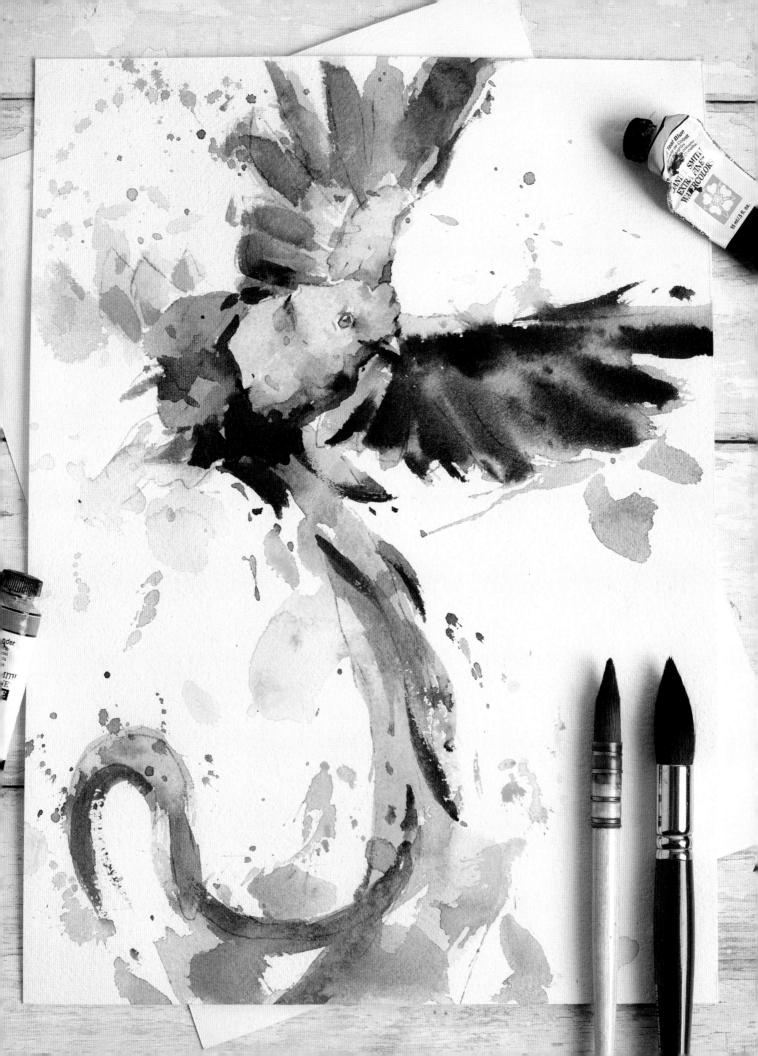

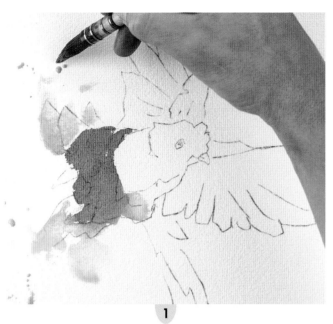

1

Mix quinacridone red and pyrrol red in equal proportions and use the size 1 mop to paint in the red parts of the quetzal. Use lavender to add the shorter tail feathers at the back of the body, and a few spattering marks to suggest movement.

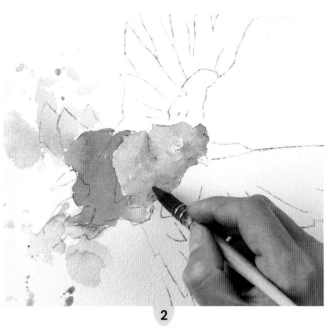

2

Once the red is completely dry, use watery cobalt teal blue to paint the body, head and neck. Leave a little white paper around and within the eye. At the bottom of the body, introduce a green tinge by adding a little aureolin. To this mix, add phthalo blue for darker details.

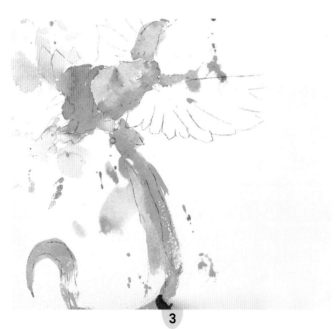

3

Using very watery phthalo blue, paint the blue patches on the wings along with the long tail feathers. Add a little aureolin to the colour for some of the tail feathers, too. Aim to convey lots of movement with your brushstrokes, and add spattering liberally.

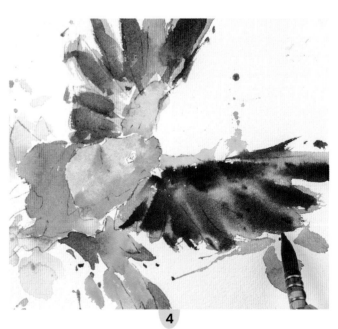

4

Paint the wings with a watery purple mix of phthalo blue and a little quinacridone red. Use the shape of the brush to help you get the feather shapes by pressing down at the start of each brushstroke and lifting away to taper the mark. Working wet in wet, make a creamy mix of phthalo blue, quinacridone red and a little aureolin and use this for some darker marks.

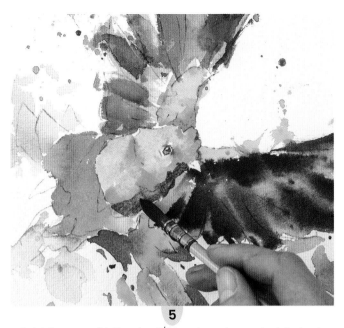

5

Paint the eye with the size 3/0 brush and a neutral dark mix of phthalo blue, quinacridone red and aureolin. Leave a little highlight, and lift out the lower part of the eye. Use a creamy mix of phthalo blue and cobalt teal blue to detail the head to help define the beak and neck.

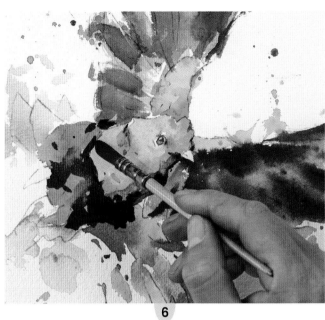

6

Working wet into wet, move on from the head to detail the body, introducing quinacridone red initially, then pyrrol red further from the head. Soften in the markings if necessary for a soft feel.

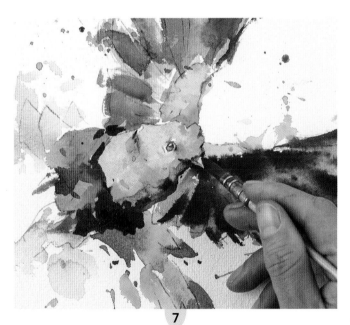

7

Treat the feet very simply with a milky dark mix of phthalo blue, quinacridone red and aureolin. Use aureolin to paint the beak, allow to dry, then strengthen the tone with another layer for shading and shape.

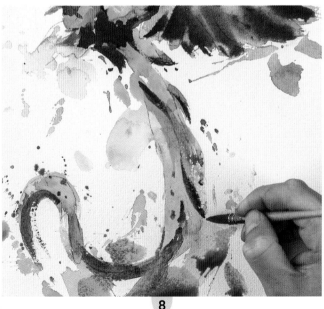

8

Use lavender at a milky consistency to detail the short tail feathers at the back, then swap to the size 1 mop brush to paint the long tail feathers with bold brushstrokes of phthalo blue and cobalt teal blue – keep the colours distinct for maximum impact.

PEACOCK

A beautiful bird that could easily become overcomplicated. The aim here is to give a suggestion of those wonderful tail feathers, but in a gentle way that allows the bold shapes and exotic features of the face and head to stand out.

Focusing on the flowing greens and blues while retaining the clarity of pink in the tail feathers will help make this one pop.

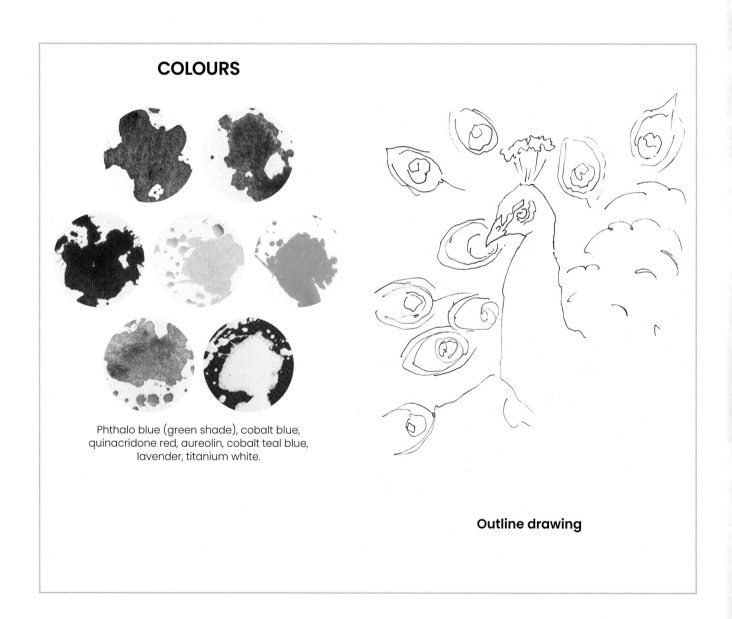

COLOURS

Phthalo blue (green shade), cobalt blue, quinacridone red, aureolin, cobalt teal blue, lavender, titanium white.

Outline drawing

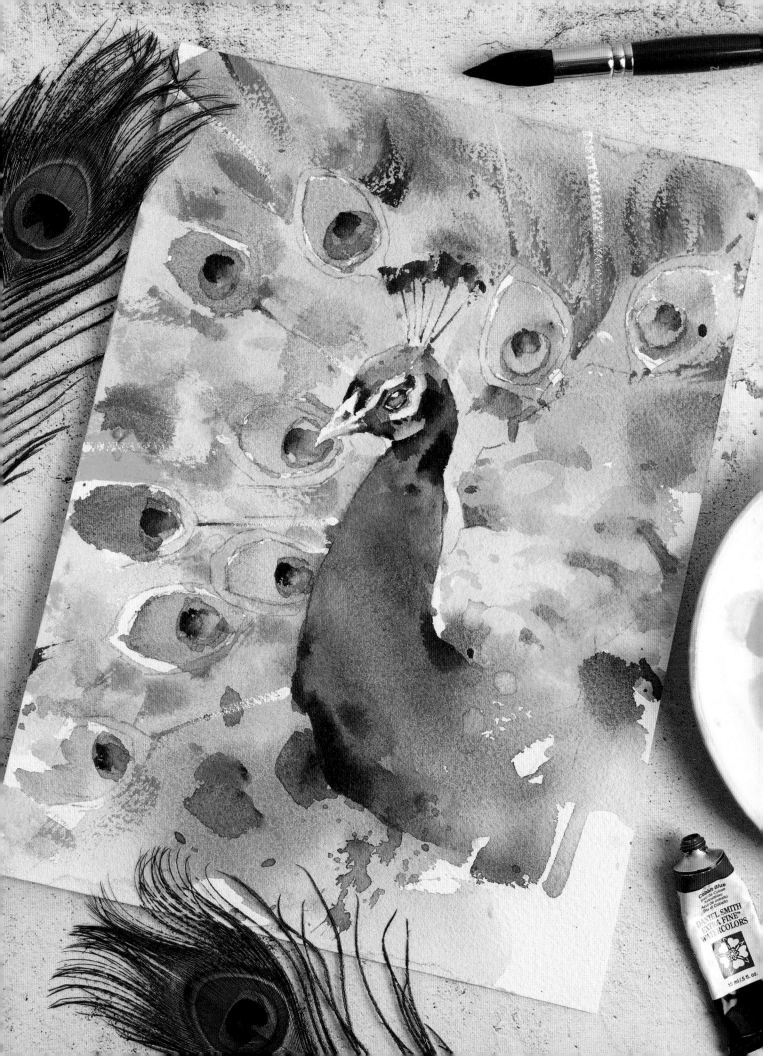

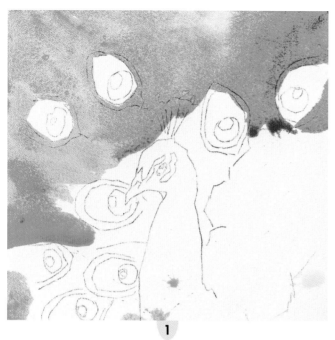

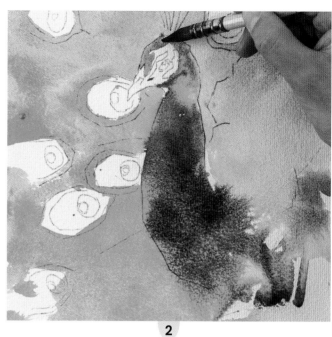

1

Use the size 12 mop to apply cobalt teal blue all across the peacock's tail. Add touches of cobalt blue and/or aureolin wet in wet to vary the colour; but be careful to leave the 'eyespots' of the feathers clean.

2

Use creamier phthalo blue to paint the peacock's body. Swap to the size 1 mop to start on the head, where a little more precision is needed.

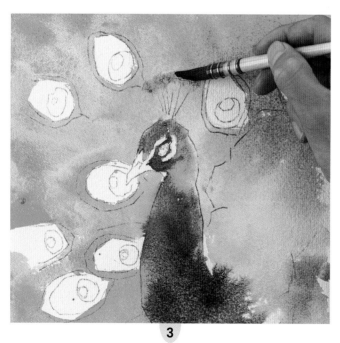

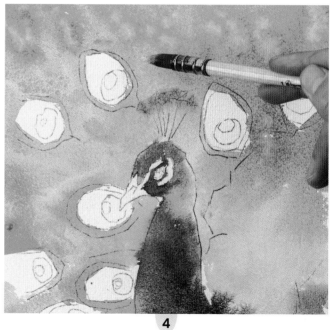

3

Use the point of the size 1 mop to pick out the details on the face with creamy phthalo blue – be careful to keep the white markings sharp. Use the same mix wet in wet for the tips of the crown.

4

While the paint remains wet, spatter in some touches of lavender across the top of the tail. This is a heavier, opaque pigment, so it will create interest and texture as the spatters 'bloom' in the wet paint.

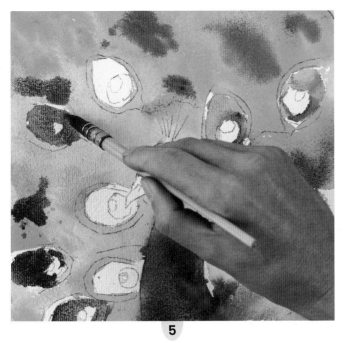

5

Mix lavender with a little quinacridone red to a milky consistency. Wait until the tail is nearly dry, then use this to paint in the borders around the eye spots in the tail so that they blend in just a little.

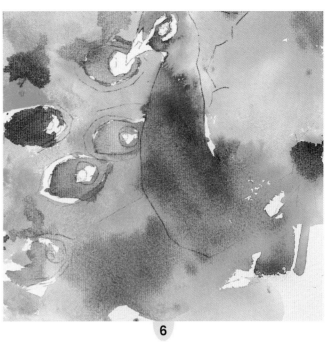

6

Work all the way round the tail to paint in the eye spots before the paint dries. You can spatter the same mix around the tail, too, to add some interest and variety.

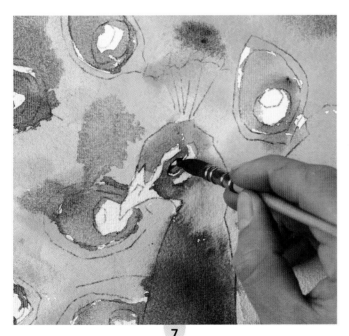

7

Using the size 3/0 brush, paint the eye with a rich dark mix of phthalo blue, quinacridone red and aureolin. Lift out the lower part of the eye.

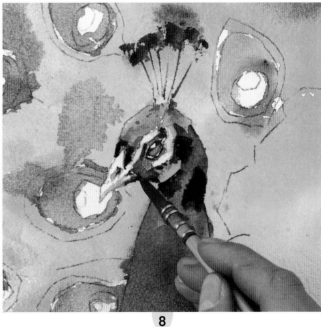

8

Use thick, creamy phthalo blue to develop and detail the head and crown, aiming to suggest texture here. Swap to the size 1 mop to add shadow to the neck with the same mix, and add lavender shading to the beak with the size 3/0 brush.

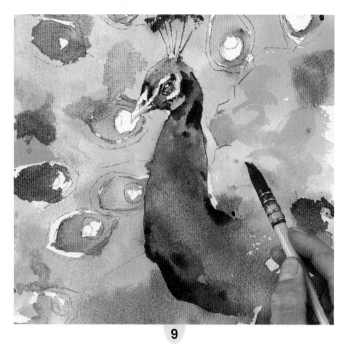

9

Use the size 1 mop to strengthen the shadows with milky phthalo blue, then use cobalt teal blue to develop the background tail feathers a little. Start light, and strengthen the markings as necessary. Allow to dry completely.

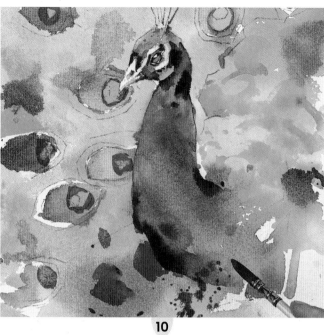

10

To paint the eye spots in the tail, use the size 3/0 brush to make a watery mix of phthalo blue and lavender (the lavender is quite opaque, so it gives the colour a little covering power). Use this to block in the lighter blue of the eyes – and add a little spatter at the bottom, too. Allow to dry.

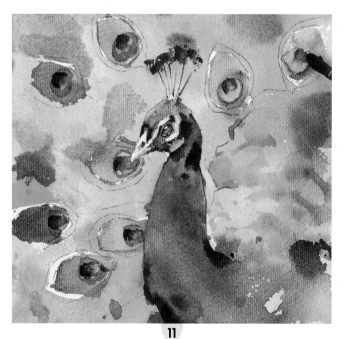

11

Paint the centre of each eye spot using thick phthalo blue, softening the base with a damp brush.

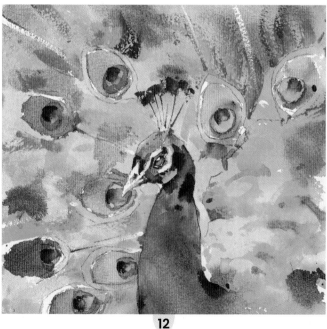

12

Once dry, use the size 1 mop to add dry brushmarks with cobalt teal blue, then titanium white to make the tail pop.